Fig. 1. Gaspar Romero. *Daisies and lemons.* An excellent watercolor in which Gaspar demonstrates his technical capacity by reserving spaces in which to paint the yellow daisies and leaving some of these white spaces in the upper area so as to create luminosity in the area where the light is more concentrated also. Observe the synthesis of the whole and especially of the vase and of the cut ends of the daisy stalks in the water.

Fig. 2. Jordi Segú. *Landscape*. Artist's collection (a watercolor painted especially for the inside cover of this book). With the agility of the professional expert Jordi Segú shows us here an example of an exercise in spontaneity and synthesis. Notice how he has chosen to place a tree in the foreground as a framing device which heightens the sensation of space, the third dimension of the landscape .

PRACTICAL COURSE IN
WATERCOLORS
DIVERSE SUBJECTS STEP-BY-STEP
JOSÉ M. PARRAMÓN

Fig. 3. José M. Parramón (b. 1919). *Landscape of Rupit* (fragment). It was in this village in the province of Barcelona that I painted a sketch and took a photo. I later painted the watercolor in the studio, well actually at Paco's house. While I was painting, Paco, the photographer, took photos of the various stages and development of the work. This process and the finished work can be seen on pages 86 to 91, at the end of this book.

General editor: José M. Parramón Vilasaló
Texts: José M. Parramón and Gabriel Martín
Edition, layout and modelling: José M. Parramón
Front cover: J. Gaspar Romero and José M. Parramón

Photochromes and phototypesetting: Novasis, S.A.L.
Photography: Studio F. Vila Massip.

1st Edition: October 1997
© José M. Parramón Vilasaló
© Exclusive edition rights: Ediciones LEMA S.L.
Edited and distributed by Ediciones LEMA S.L.
Gran Via de les Corts Catalanes, 8-10, 1st 5th A
08902 L'Hospitalet de Llobregat (Barcelona)

ISBN 84-95323-08-7

Printed in Spain

Table of Contents

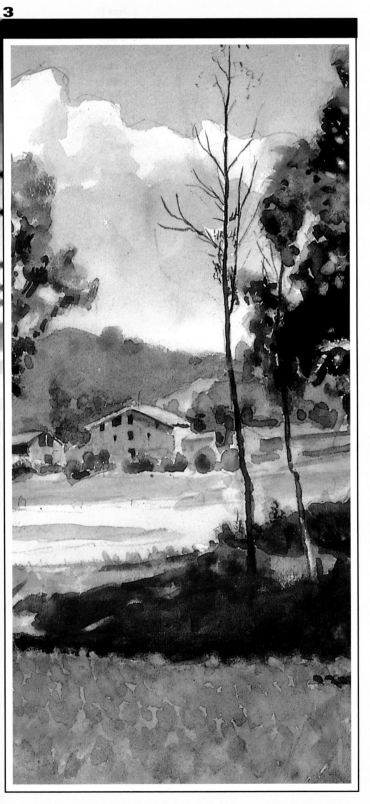

3

4

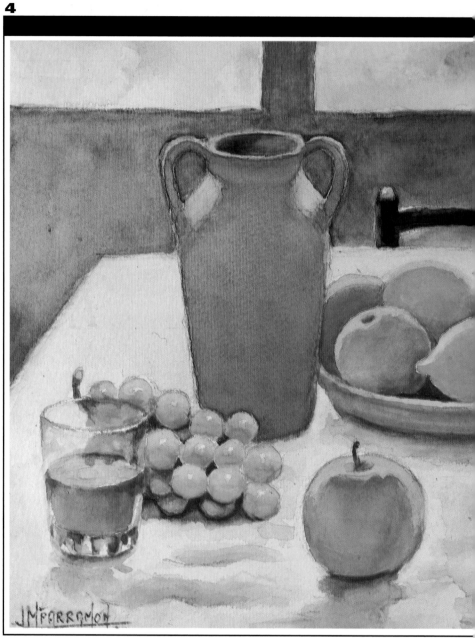

5

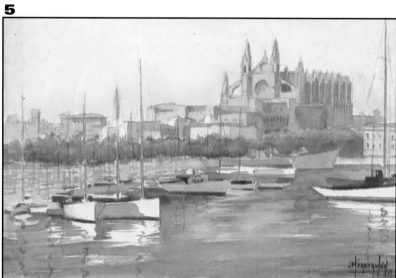

Fig. 4. José M Parramón (b. 1919). *Still life of fruit and a glass of wine*. Most of the still lifes by the famous American watercolorist Charles Reid are painted against the light. I was in the studio trying out different forms of lighting when I remembered Charles Reid's pictures and decided to use this back lighting. The well known historian, Heinrich Wölfflin, was right when he said, *"A painting owes more to other paintings than to the observation of nature"*.

Fig. 5. José M Parramón. *The Cathedral, Palma de Mallorca*. My talented painter friend, Forteza, was right when he said to me, *"If you are going to paint in Mallorca you will see that the sky is rose color and everything is rose tinted"*.
I remembered and kept that in mind when I painted this watercolor of the cathedral in Palma de Mallorca.

Introduction

The French pedagogue, **Jean Guitton**, talking about how to decide on and create the content of a piece of writing, recommends a formula which I have applied to the more than forty books on the teaching of painting and drawing that I have written so far. The formula is very simple:

**" You say what you are going to say;
you say it;
then you say what has been said".**

So, now that we are reading another of the five volumes in the series *Practical Course in Watercolors*, it is time *"to say what has been said"*, that is, group together and summarize, in a series of practical steps, the information and instruction contained in the previous volumes. So, we are going to paint —and I say *"we are going to paint"*, as I hope that you the reader will also paint—, we are going to paint a series of step-by-step developments of themes that include landscapes, interiors, still lifes, sketches, animals, flowers, portraits, the human head, body and the nude. We will remind ourselves of the technical and artistic teachings on composition, interpretation, color, color mixing and contrast and harmony, that were dealt with in previous books. Here we will enhance all this knowledge with new methods and techniques based on the use of new materials. These are colored watercolor pencils and pastels, watercolor graphite and watercolor and gouache. We will also briefly look at some important, practical aspects of perspective.

But all this will be of little use if you do not work, do not practice, if you do not paint! And do not tell me you cannot, that you have not got time or that you are not inspired. Talking of time to paint, the famous painter **Eùgene Delacroix** says in his diary, *"Everybody is surprised at how much I paint. Instead of talking and rushing about from one place to another as most people do, I lock myself away in my studio"*. You do not have to lock yourself in your house to paint but yes, you do have to find a little time each day or every two days, and especially on weekends, to dedicate to drawing and painting instead of chatting and rushing around as most people do. **Henry Matisse**, the creator of Fauvism, had a very precise idea about the necessity of working. **Matisse** said, *"You have to work a certain number of hours every day. You have to work like a workman. Anyone who has done anything of any worth has worked like that"*. And finally we must turn to **Picasso** as the example of maximum dedication. In some recent declarations by his daughter, **Maya Picasso**, in which she lamented the *"ridiculous things that are said about my father's private life"*, **Maya** said, *"Everything about his sexual antics is invented. Everybody wants to know everything about his wives or lovers, but they forget that more importantly he was an artist, a painter who painted 14 or 16 hours a day and who could not go for more than three days without immersing himself once again in his studio"*. As for inspiration, the very same **Picasso** said that he did not just wait for it to come but that it came to him through his work, which was the best way to find it. The French writer **Honoré de Balzac** expressed the same idea with these words, *"Waiting for inspiration is a waste of time. What one has to do is grab the materials and dirty your hands"*.

Come on then! Get hold of your materials and draw, paint! Contained in the pages of this book are a great number of ideas and proposals to practice drawing and painting, how to draw and paint still lifes, a subject which is ideal for working on at home, on your own, without witnesses. You can choose

Fig. 6. José M. Parramón, author of the collection *Practical Course in Watercolors*, also author and editor of over forty books on the instruction of drawing and painting wich have been translated and published in over sixteen countries including Germany, England, France, Italy, the United States, Russia and Japan.

and arrange the objects in order to practice the art of composition. Make sketches of your friends or family or people in the street, in a square or in a park. You can draw your pets if you have any, the dog, the cat or the canary. Or better still go to a farm or the zoo where you will find a never ending supply of subjects. It is great fun, which only you the artist can experience.

I shall leave you here with your exercises and activities and I hope that you will paint more and better watercolors.

José M. Parramón

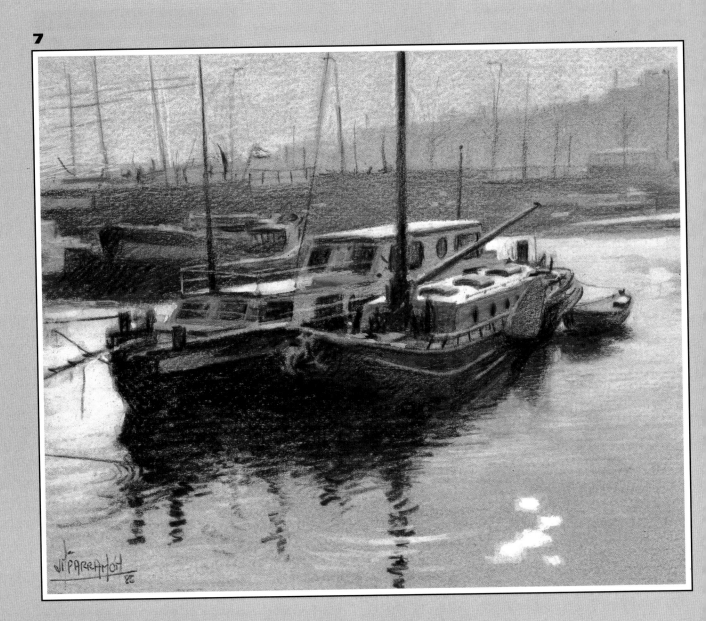

Fig. 7. José M Parramón (b. 1919). *Boats in Amsterdam Port*. Artist's collection. In the following pages I will talk to you, with the help of easily assimilated images, about mediums and techniques, about watercolor painting, watercolor pencils, watercolor pastels and watercolor graphites. In order to approach the subject, observe here, in this painting an example of drawing-painting carried out with the use of colored Prismalo 11 de Caran d'Ache watercolor pencils on Canson Mi Teintes gray paper. In this case the whites are painted with a white pencil.

DIVERSE TECHNIQUES STEP-BY-STEP

In the next few pages we shall leave aside watercolor painting in its traditional form in order to talk about other possible mediums available for watercolor painting. I refer to the colored watercolor pencils and crayons, watercolor graphites or soluble lead pencils. No, they are not merely classroom materials. I myself used colored watercolor pencils to paint subjects like that illustrated on the facing page. Colored watercolor pencils are well known, but watercolor crayons not so well, and the soluble graphites are much less well known.

As you will be able to see in the following pages, pastels as well as graphite offer the possibility of making quality watercolors. With pastels, bright colors are possible and with soluble graphite, a monochrome wash of many shades can be achieved. In the following pages there is also a section dedicated to the techniques and possibilities of watercolor and gouache. I invite you —I urge you— to follow the contents of these pages, trying out and painting with these mediums as you go. You can be sure of finding new techniques and interesting facets of watercolor painting.

Pencils and Soluble Crayons

Fig. 8. Colored pencils, crayons, pastels and also soluble graphite pencil lead form a series of media which are well worth trying and getting to know. As you can see in this spectacular illustration, there are wide selections of up to 100 colored pencils. Why so many pencils you may ask? The answer is to be able to have many shades at your disposal in order to produce a wide range of tones, directly, without the necessity of mixing because even though they are soluble they are not as flexible nor do they have the same intensity as traditional watercolors. But we are going to try them out and get to know them just as I propose, starting from the next page.

8

Watercolor pencils and crayons can be used just like traditional pencils and crayons but with the difference that, when the strokes are dampened, the colors and tones dissolve, and behave just like traditional watercolors. This special quality that these pencils and crayons possess makes them an ideal medium with which to start painting, mixing colors and investigating aspects of contrast and color combination.

The massive commercialization of this product provides us with an extensive variety of colors and different brands (fig. 8). You can buy these pencils loose or in ranges of colors which usually come in a metallic box. If you wish to begin painting, I recommend that you acquire a medium sized box with a selection of 24 or 36 colors. When you have become familiar with the medium you can move on to a wider range or you can add extra colors to your collection. This way you will be able to enrich the shades of your drawings and paintings.

On this page you can see the variety of boxes and ranges currently available on the market. On the left you can see the collection of watercolor pencils for artists available from Faber-

Castell which come in ranges of 12, 24, 36, 72, or 100 colors. The collection of 100 pencils come in a luxurious wooden briefcase. Also available under the same name are the Albrecht Dürer series of watercolor pencils in boxes of 12, 24, and 3 colors. All the colored pencils produced by the Swiss manufacturers Caran d'Ache are water soluble (on this page, in the box on the right). They produce two different color range Prismalo 1, the normal range and soft range, Prismalo 2. They offer collection with a maximum of 4 colors.

Rexel Cumberland, apart from offering the usual range of watercolor pencils, have commercialized squar graphite pastels which are not encase in wood and are 8 millimeters wid and 12 centimeters long. They ar coated in lacquer to avoid staining th fingers. They are ideal for painting backgrounds or large areas. They ar available in boxes of 72 individua

colors and also in smaller special selections of 12 and grouped in different ranges.

In the center of the illustration we can see the collection of soluble crayons. This is one of the most recent additions to the range of materials available for watercolor painting. Just like pencils, these are water soluble. Crayons are softer with a more opaque and intense result. They are available from Caran d'Ache, Rexel Cumberland or Faber Castell.

You should also bear in mind that other brands such as Conté, Stabilo, Koo-i-noor etc. also offer similar selections of colors to those mentioned. Remember that all these makes also provide additional colors. The lead used in watercolor pencils is generally made up of pigments, a soluble agglutinant and a glue which hardens it. The pencil is a medium in which the movement of the hand and fingers control the evolution of the drawing with very little difficulty. This characteristic allows for a good finish to sketches and permits you to create fine detail on smaller works. For this reason, water soluble colored pencils are very useful for sketching outside as they are light and easy to carry and give a fresh, spontaneous look to any work.

Techniques and Tests

Watercolor pencils should be used in the same way as normal colored pencils without forgetting however that if we wet the marks the color will dissolve and will assume the appearance of traditional watercolors. Observe the color tests in figure number 9. The regular pink tone (A), has been produced with a red pencil, without the addition of water. In the next image we can see the same regular tone (B), but here it is dampened. In the following image (C), you can see a regular pink colored tone painted with red watercolor paint. In the images that follow we have done the same but with graded red washes. In D the graded wash has been produced with a red pencil, without water. In E with a red pencil and water and in F the gradation has been achieved with red paint.

Fig. 9. Here we have a pink tone painted in A, with a colored pencil without water. In B, using the same pencil but with water, and in C, the same color painted in watercolor. In D, a graded color painted with a red pencil. In E, the same but with water, and in F, an identical red gradation painted with watercolor paint.

Figs. 10 and 11. The pencil strokes have a different texture depending on the grain of the paper, fine grain (10), or coarse grain (11). For the technique of watercolor pencils, fine grain paper is recommendable.

Figs. 12 and 13. When a drawing-painting done with colored pencils is dry it is always possible to draw on top with the white pencil, pressing sufficiently hard so as to produce a pastel color effect.

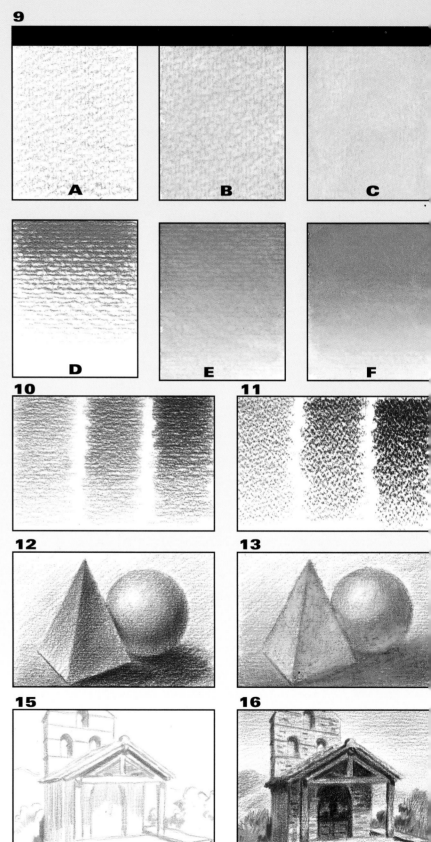

When drawing with colored pencils, make sure that the grain of the chosen paper is adequate for the size of the drawing. For a small work it is advisable to use a fine or medium grained paper (fig. 10). For a larger work, choose a medium or rough grain (fig. 11). The pyramid and the sphere in figures 12 and 13 show differences although they have been drawn with the same colors. The difference lies in the fact that I have painted over the form on the right with a white pencil, leaving a whitish patina on the surface. See now in figure 14 the different colors obtainable with colored pencils depending on whether we paint with yellow over a blue tone or with blue over a yellow tone. Notice how, in the second version, the green is more intense. When painting with watercolor pencils it is a good idea to do the initial drawing with colored pencils, sky blue, gray or ochre for example, and not with a lead pencil as this would dirty the subsequent colored pencil colors (fig. 15 and 16).

See the results of the same exercise carried out on the last page (fig. 9) for yourself, but with the use of watercolor crayons (fig. 17). First, we lay down a blue tone (G). Following that we have the same color having been dissolved with water (H), and then the same color painted with watercolor (I). In the following examples J, K and L the same process has been applied to a graded wash. Finally, notice the juxtaposed green and blue washes painted with undissolved crayons (M), and diluted (N).

In the next figure, observe some examples and tests carried out with a soluble lead pencil (fig. 18). We will take you step-by-step through the same exercise on the following pages. In figure 19, you can see a fragment of a landscape painted with watercolor pencils, which is there to remind you that in these techniques and in all those mentioned in these pages, the whites, as in traditional watercolors, are the white of the paper.

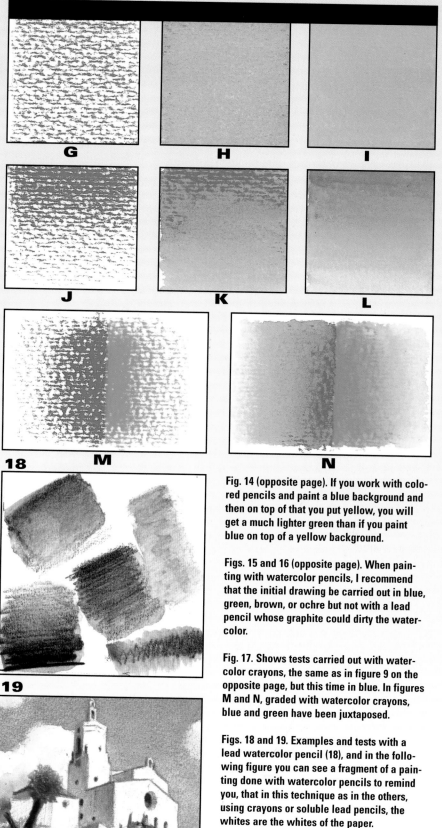

Fig. 14 (opposite page). If you work with colored pencils and paint a blue background and then on top of that you put yellow, you will get a much lighter green than if you paint blue on top of a yellow background.

Figs. 15 and 16 (opposite page). When painting with watercolor pencils, I recommend that the initial drawing be carried out in blue, green, brown, or ochre but not with a lead pencil whose graphite could dirty the watercolor.

Fig. 17. Shows tests carried out with watercolor crayons, the same as in figure 9 on the opposite page, but this time in blue. In figures M and N, graded with watercolor crayons, blue and green have been juxtaposed.

Figs. 18 and 19. Examples and tests with a lead watercolor pencil (18), and in the following figure you can see a fragment of a painting done with watercolor pencils to remind you, that in this technique as in the others, using crayons or soluble lead pencils, the whites are the whites of the paper.

Painting with Watercolor Pencils

20

We are going to see how it is done, we are going to paint. You too! Right, take your box of watercolor pencils, a jar of water, a rag or a piece of absorbent paper folded in four and a selection of sable brushes, numbers 8 and 12. Take some fine grained paper and begin by wetting several different colored pencil marks (fig. 20). This will help you get used to the medium, to dilute the colors to a greater or lesser extent and to make different kinds of marks depending on the amount of water. Notice the flow of the colors when in contact with water. Adding water to different colored marks can produce a great variety of effects and noticeably the mixing of colors which form the various tones and shades. This experiment gives us an intermediate stage between watercolor and drawing which combines vigorous pencil marks with the liquid, watercolor effect.

In figure 21, you can see the application of two watercolor pencils in a landscape with abundant vegetation. Notice the different shades of green, orange and russet. When painting with watercolor pencils you must bear in mind that the pencil marks tend to remain visible so you should be aware of the effect that the direction of the marks have on the form.

Fig. 20. A collection of various pre-tests on fine grained paper of some 18 x 15 cm. Drawn in several colors and diluted with water to a greater or lesser degree, tones, graded washes, pencil marks and backgrounds. Do these experiments before starting any other exercises such as those on the next page.

Fig. 21. Here we have a thumbnail sketch painted with watercolor pencils.

21

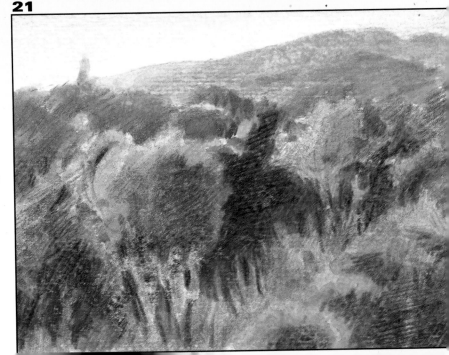

So, now we are going to start to paint a simple landscape with few apparent complications, based on the model in figure 22. Begin by sketching from the model with a light blue pencil, bearing in mind the dominant blue color of the landscape. This light blue drawing will finally be incorporated into the tonality of the whole. As I said before, at this first stage you should not use a lead pencil as the graphite from the lead will interfere with the subsequent colors. I began by drawing the structure of the buildings and of the mountains in the background. I painted the hill in the foreground, immediately behind the houses, with a series of different colored marks but still without dampening (fig. 23). Now look at figure 24, the second phase of the drawing with the houses completed. Notice the reaffirmation of the dark areas, the strengthening of color and painting of the hill behind the houses and the first coat applied to the background mountains.

22

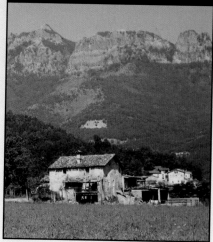

Fig. 22. The subject. The landscape that we are going to paint with watercolor pencils.

Figs. 23 and 24. The first and second stages with the blue pencil drawing and the hill behind the houses with a first coat of color (23). The drawing of the houses now finished and the hill and background mountains with a first application of water (24).

23

24

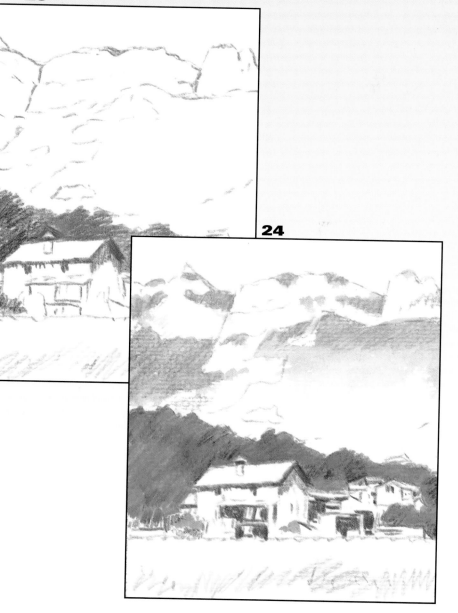

Painting with Watercolor Pencils

25

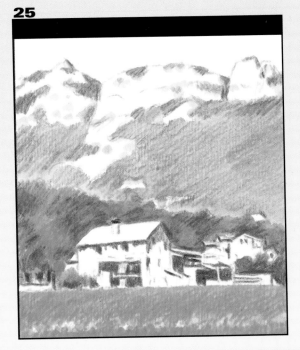

Now it is a case of coloring and drawing all at the same time, diversifying the colors and accentuating the contrasts like the green lawn for example, and intensifying the color of the hill behind the houses which by the law of simultaneous contrast brings out the white of the houses. Talking of the green of the lawn, look in the foreground at the band of yellow representing small wild flowers which has been conserved from previous steps. Notice also how the representation of the lawn has been done with small vertical hatch marks. Notice how I have added touches of carmine to the shadows running across the roofs of the houses which, at a later stage, will produce a blue-violet tinge on the addition of water. Finally I painted the wide, dark area of the mountains with a first coat of grayish blue by diluting the pencil marks with water.

So now we get to the last phase with a general intensification of the tones and colors, incorporating the light blue of the sky produced with horizontal strokes and the color of the mountains in the background; the upper area with the mixture of gray, burnt Sienna and some soft, light blue marks. In the dark, central area of the big mountain I have intensified the general with dark blue, a little carmine and dark grey. I have also intensified the hill behind the houses and the green of the lawn, and finally consolidated the color of the houses with yellow, ochre and pinks for the roofs and with yellow and soft ochre for the walls.

See for yourself how the final result reflects a quality, mixed media work, half-way between a drawing and a painting.

Fig. 25. I painted the green lawn with small vertical strokes, maintaining the yellowish strip in the foreground. The color of the hill behind the houses has been intensified and I have added a touch of carmine to the shadows on the walls produced by the roof tiles. The wide zone of the mountains has been painted with a first coat of grayish blue.

Fig. 26. Here we see a general intensification of all the colors of the central and upper area of the mountains and of the hill in the foreground, painting the sky with small horizontal marks, more green in the lawn and the addition of colors to the roofs, walls, windows and the doors of the houses.

26

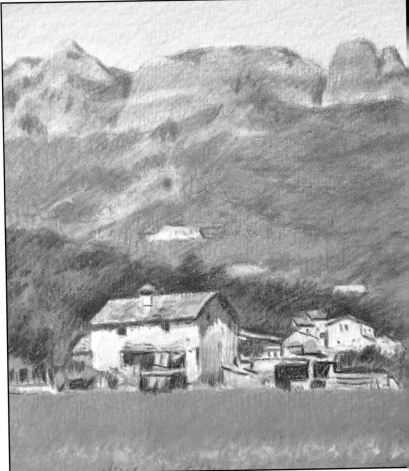

Painting with Watercolor Crayons

Recently, a variety of pastels and watercolor crayons have been put on the market and represent a valuable addition to the materials available for watercolor painting. As I explained earlier, these products are available loose or in metallic boxes (fig. 27). Watercolor crayons have their own characteristics which distinguish them from watercolor pencils. The colors spread more than the pencils which allows light colors to be placed over dark ones. Owing to the greasy agglutinant they can be spread with the fingers. This makes these crayons difficult to rub out and consequently the color will never disappear completely. Watercolor crayons are no more or less difficult to use than the pencils, but to get to know the characteristics of this medium we are going to do a still life.

Look at the model in the figure 28. You can always create your own, similar model with whatever objects you have at home.

Begin the painting by drawing the model with a gray crayon and also add the first touches of color to the fruit and decorative elements of the ceramic pot without, for the moment, adding any water.

27

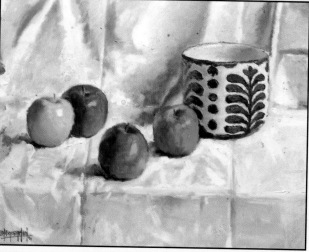

28

29

Fig. 27. Presentation box of watercolor crayons.

Fig. 28. The still life that we are going to use as a model to paint with watercolor crayons.

Fig. 29. Without water dilution, draw the model with a gray crayon and add the corresponding colors to the fruit. Begin also to work on the ceramic pot.

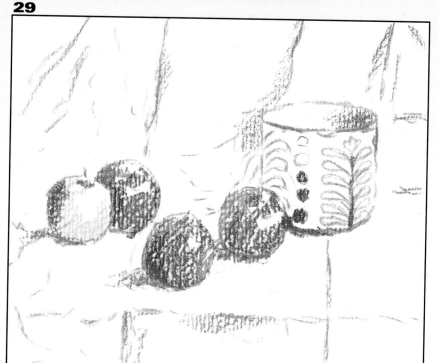

Painting With Watercolor Crayons

In the second phase I have lightly intensified the white cloth forming the background to the still life. I have added to and painted the apples and I have started to add the decorative pattern on the ceramic pot in ultramarine blue. There is one important thing that I must draw your attention to and that is the variety of whites in the cloth and the ceramic pot, especially where the light catches the fruit (fig. 30).

And so finally, the finishing touches achieved by a general adjustment of the overall colors and forms. Reaffirming and contrasting forms and colors while maintaining the range of whites and establishing a general color harmonization between the grayish forms in the background and the bright apples.

If you have put these steps into practice, you will have discovered that these watercolor crayons are easy to use and ideal as a means for painting with watercolor.

Fig. 30. The strengthening of color determines the form of the background cloth of the still life.
I have drawn and watercolored the fruit and the ceramic pot, making sure to conserve the range of whites that make up the cloth, the ceramic pot and the shine on the apples.

Fig. 31. Notice the general intensification of all the colors, with special attention paid to the forms and colors of the background cloth, the apples and the ceramic pot.

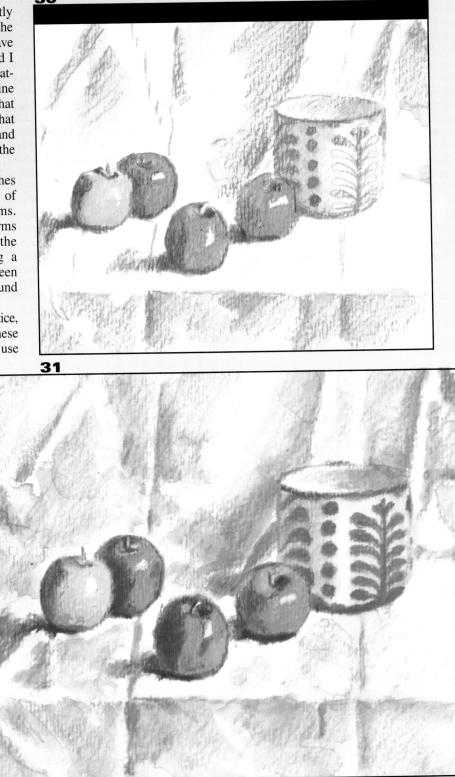

30

31

Using Watercolor Lead Pencils

nglish lead pencils, Derwent ketching and Dark Wash by Rexel umberland are now available on the arket. They are 8B soft pencils and an be used for watercolor, that is to ay, they are water soluble (fig. 33). As ar as I know, these pencils are not vailable under any other name.

et hold of one of these pencils and try out. Draw a flat tone or some shading ig. 33A), and then apply a wet brush n top (B). Repeat the process and vhile the shading is still wet, draw on op of it with the pencil and you will chieve a much more intense black C). Notice that, by making a very ntense black and then wetting it with a rush, you can produce a gray, just as ' it were a watercolor (fig. 34).

o this and other tests before ttempting to draw the djoining portrait (fig. 32).

o, begin the picture by dra-ring on fine grained, quality rawing paper, starting with normal 2B pencil. Once ne head is constructed the oluble pencil comes into lay. Begin with a fairly ark toned, general shading ig 35). Now we can move n to watercoloring with a ood number 9 or 12 sable rush and as in watercolor ainting, always working rom less to more. First, vork over the applied marks nd then make additions vith the pencil and brush.

Jow try —something that I ave not said up till now but vhich you must always bear in mind— to control the direction of ne strokes, on the face in circular and horizontal directions and or the hair, by following the direction of the natural hair (fig. 36).

32

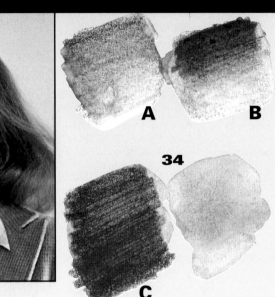

33

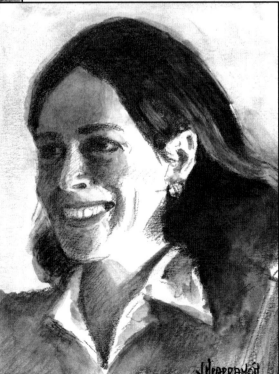

Fig. 32. The model, a woman's face for drawing with a soluble lead pencil.

Fig. 33. A graded wash done with a watercolor lead pencil (A), the addition of water (B), and now with new marks over the previous graded wash.

Fig. 34. From an intense, watercolored mark you can produce a fixed tone with a well loaded brush, as if the original mark was watercolor paint.

35

36

ig. 35. First, with a normal 2B pencil, draw in a linear way. Then draw the eatures with the soluble pencil and later add highlights and shadows in dar-er tones. Be careful with the white range. The watercolor pencil is not easy erase.

ig. 36. Now draw and paint, from less to more, following the direction of the air.

Watercolor and Gouache Techniques

The medium gouache, also known as tempera, is composed of the same ingredients and agglutinants as traditional watercolor paints although it has a high percentage of pigments which makes it a more opaque paint. The utensils and materials necessary for painting with the mixture of tempera and watercolor are the same as those for watercolor painting (fig. 37). Water, sable or synthetic brushes, small pots for mixing the tempera and rags or absorbent paper. The paper should be fine grained or better still, fine or medium grained drawing paper of 250 grams. Tempera paint is thick and comes in tin tubes, like oil paint, or in small glass pots. When diluted with water it looks like watercolor paint but with a light patina covering of pigment which increases with the thickness of the paint.

For the inexperienced painter, the worst problem with the tempera technique is the problem of painting graded washes or gradations. We are going to look at and practice this by carrying out wet and dry gradations and also with the drybrush technique. Look at and read the illustrations and texts of figures 38, 39, 40 and 42.

37

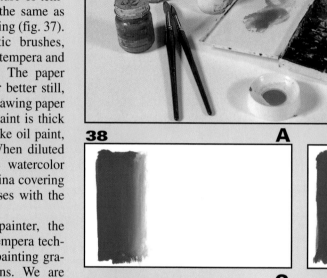

Fig. 37. Material for tempera painting.

38 **A**

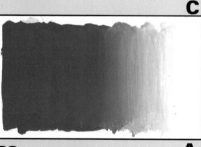

C

Fig. 38. An example of a wet graded wash. Begin by painting a third of the 7 x 10 cm rectangle with very thick, ultramarine blue watercolor paint. Clean the brush and paint the rest of the paper with white tempera (38A). Clean the brush and squash the end to get a split hair or "comb" effect (see fig. 4). Painting in a vertical direction, dilute the blue with the white until you get a perfect colour gradation.

40

Fig. 40. By dampening a number 9, 10 or 12 brush and squashing the end with your fingers, you will get a split hair or "comb" form which is ideal for diluting and blending color gradations.

39 **A**

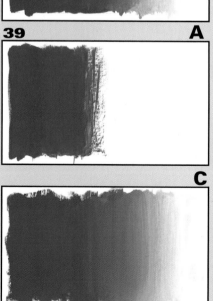

C

Fig. 39. An example of dry colour gradation. Paint half of the 7 x 10 cm rectangle with very thick, ultramarine blue watercolor paint and paint the other half with white tempera. Wait for the colors to dry completely (fig. 39A). With the damp, split hair brush (fig. 40), dilute the blue and white by brushing vertically and do not stop until a perfect color gradation is achieved (39B and C).

41

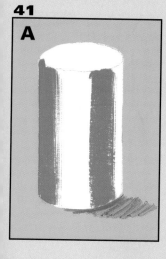
A

B

C

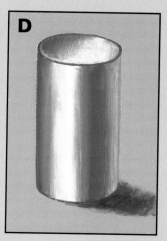
D

We will now see how to paint a graded wash of a cylindrical form. Begin by drawing a cylinder. Following this, using a mixture of cobalt blue and a little white tempera, paint two vertical strips (fig. 41A). Add white tempera to the space between the two strips and blend it into the aforementioned blue strips (figs. 41B and C). Paint a strip of light blue to represent the reflected light. Now you should gently blend in and harmonise the colors with soft, up and down brush strokes (fig. 41D).

42

Fig. 41. Procedure for painting a cylinder with the corresponding graded washes.

Fig. 42. The painting of a gradation with a dry brush. First paint with light blue. Wait for it to dry, then load the brush with a little water and thick ultramarine blue. Paint on top of the light blue by dragging the brush.

We will finish by mentioning how to paint a color graded wash on a sphere. First draw a sphere in pencil and establish light and dark areas as in figure number 43A. Divide the sphere in two areas of color. An upper, light blue area, leaving white for the shine and a lower area divided into three circular strips (fig. 43B). Without waiting for it to dry, dilute and spread the strips (fig. 43C). Finally, clean the brush, squash the point to make a split hair form and by brushing in a spherical direction dilute and blend the tones to produce a sphere (fig. 43D) These are the methods for obtaining a wet, dry or spherical graded wash. Some of the forms in watercolor and tempera painting in which color gradations abound, are human figures or portraits, as we will see on the next page.

43

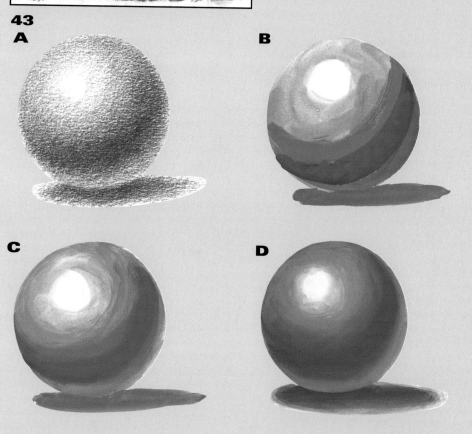

Fig. 43. Paint the upper part in light blue and leave the white patch for the shine and the lower part with three circular strips (43B).

Dampen the strips (43C), and using the split hair brush in circular strokes so as to blend and harmonize the color (43D).

Painting a Portrait in Watercolor and Gouache

44

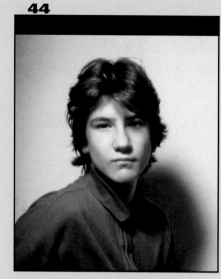

We are going to paint a portrait in watercolors and tempera, and as a model I have chosen my grandson (fig. 44).

I begin by drawing the head, the chest and the facial features (fig. 45), keeping in mind the rules of the canon of the human head (see pg. 67 of this book).

In the next figure, number 46, I paint the background with white tempera mixed with a little English red, and a bit of cobalt blue. I also apply the first coat of the gray shirt using Payne's gray watercolor and white tempera.

After that, I paint the first hints of color and form with sepia colored tempera for the hair and a sketch of the facial features (fig. 47). The same sepia color, helped by coat of English red is used to sort out the eye-brows, the eyes, the nose and the mouth and the facial shadows in general. During all this process I am very aware of the rules of the canon of the human head. But the said canon is not an exact rule as everybody has their own features, but knowing the canon will help you to draw and paint anyone's face.

I finish this phase by applying touches of Payne's gray mixed with tempera white to the shirt and resolving the shadow on the wall with sepia tempera, a bit of watercolor, cobalt blue and also a bit of white tempera. In the next figure, number 48, I have worked on the highlights of the hair with English red watercolor and I have intensified the colors and shadows of the face, which incidentally are quite strident and not very harmonized.

Figs. 44 and 45. Model and drawing for painting a portrait in gouache, also called tempera

Figs. 46 and 47. I paint the background and the shirt (46), I sort out the hair reserving the white for the hair shine, facial highlights, shirt and I paint the shadow on the wall.

45

46

47

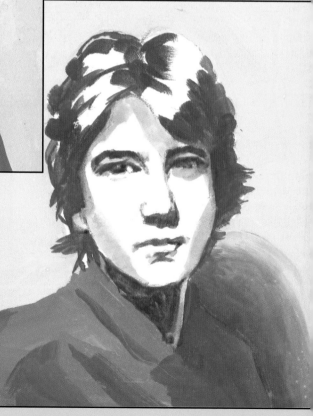

48

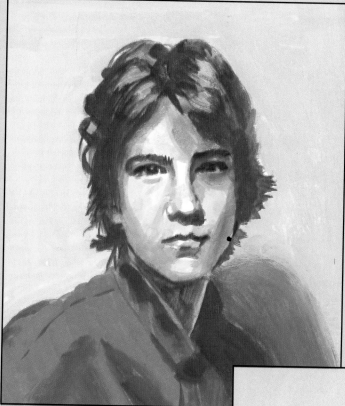

49

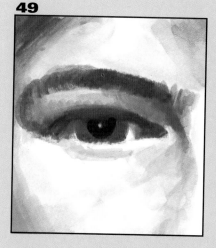

Figs. 48, 49 and 50. I continue by modelling the face and then I start on the final stage in which I paint the features, the eye-brows, the eyes (see fig. 49), the nose and the mouth. I work on the colour gradation with a split hair brush.

50

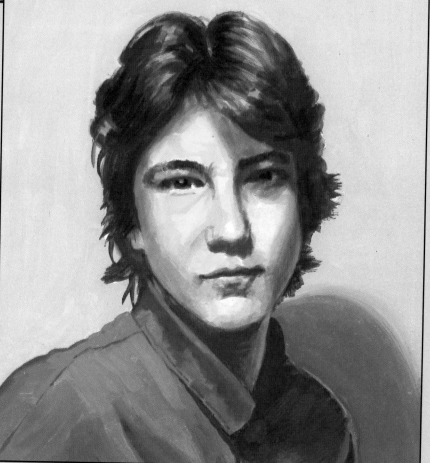

But this is not a problem because when painting with watercolors and tempera it is always possible to rectify, repaint and paint over, thus covering what has already been done. That is how I finished the portrait (fig. 509), with general finishing touches, redoing the color and the shades of the face by painting with white tempera and English red, and by grading and harmonizing with the split hair brush. I have also retouched and finished the hair by ordering and determining the bright areas and intensifying the shadows. I have also adjusted the form of the eyes, nose and mouth. Look at this carefully finished eye in detail (fig. 49) in its original size. Observe the finish on the nose, the shadows of the nose and the form and color of the mouth. Compare this final result with the last figure, number 48 and notice the changes I have just mentioned. Finally, I have repainted the shadow on the wall and the dark folds of the shirt by painting on top and covering over, thanks to the opacity of the tempera.

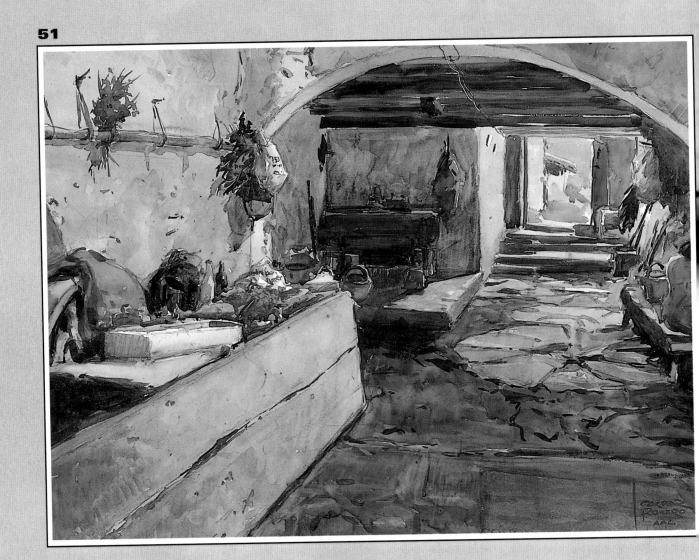

Fig. 51. Gaspar Romero. *The interior of a windmill, high in the mountains.*
Property of the artist. The step-by-step development of this painting appears in
this chapter. Gaspar Romero painted this picture a long time ago, some five or
six years ago, and he has repeated it for this book with the same fine drawing,
the same excellent coloring and the same exact perspective (parallel perspecti-
ve from a vanishing point), and in this way complementing the brief instructions
on perspective that appear in this volume *Practical Course in Watercolors.*

DIVERSE SUBJECTS STEP-BY-STEP

A series of step by step developments of watercolor subjects painted by professional experts begins on the next page. Diverse subjects which range from the painting of flowers to the nude, from a sketch to a portrait, painting animals, urban landscapes, interiors, marinas, still lifes, the figure and landscapes. There are two sections on perspective, eight pages in total, which seem to me to be essential for this to be a complete practical watercolor painting course. One consists of six pages on how to draw mosaics, how divide space and depth, and how to draw stairs. Another two pages are on how to draw the human figure in perspective. It is very important to learn and practice the rules governing perspective although in time one sorts out these problems by eye and feeling, by studying and "copying" the model. I have tried to make these step-by-step developments diverse and easy to understand. Diverse in themes and contributors, and easy to understand by the use of a variety of texts that, with the agreement of the artist-author, I think are clear and easy to read. That is what I hope to achieve in this *Practical Course in Watercolors.*

Painting Flowers: Daisies and Anemones

Carmen Freixas, the famous watercolorist and specialist in flower painting, is going to paint a composition of daisies and anemones for us. The daisies, white with yellow corollas and the anemones are red and violet (fig. 52)
Carmen Freixas paints standing up, with a metallic easel and a 3 mm drawing board on which she attaches the paper with drawing pins. She uses various sable brushes, six or seven, which she holds in her left hand while with the right she paints, alternating between sizes 6 to 12 brushes. To wash out and clean the brushes she always uses a cotton cloth. She uses a small pot for the water, which she does not usually change and she works with a paintbox with the following creamy colors:

<div align="center">

cadmium yellow, yellow ochre, orange, vermilion, cadmium red, carmine red, sky blue, cobalt blue, ultramarine blue, Hooker green and burnt umber.

</div>

She does not use Payne's gray or black. She also eliminates emerald green from her paintbox.
Interestingly, although the model consists of two crystal jars (fig. 52), **Carmen** draws and paints the bunch of flowers separately, without the jar or vase. See the finished drawing in figure 54. **Carmen** starts her drawing with light strokes of a number 2 pencil. She fits things together and studies the dimensions and proportions. Once this is completed she then reinforces the marks with a 2B pencil, drawing confidently. Given that she is painting daisies I asked her if she ever uses liquid eraser. She said, "no, absolutely not".
Before starting to paint, she gently rubs out the pencil marks. In fact, I asked **Carmen** if we could keep the stronger lines as softer marks would not show up in a photo.
Carmen does not usually wet the paper before starting to paint. She started her painting with some soft touches of yellow for the corollas of the daisies and now, with vermilion, cadmium violet and carmine she puts some touches on the anemones, as we can see in figures 55 and 56. While she paints one anemone with cobalt blue and carmine, which according to her she invented, she explains, *"I am not tied to the forms, lights, shadows and colors of the model, but I diversify, change and interpret as I wish"*. Put

Figs. 52 and 53. The subject composed of a bunch of white daisies and red and violet anemones (52); and the material with which Carmen Freixas works. Notice the small sized water pot, the cotton rag and the paintbrush holder.

Fig. 54. The drawing, started with a normal number 2 pencil and then reinforced with a 2B.

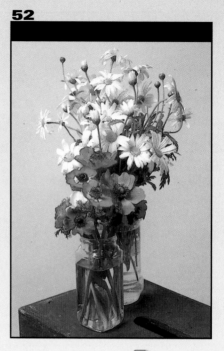

52

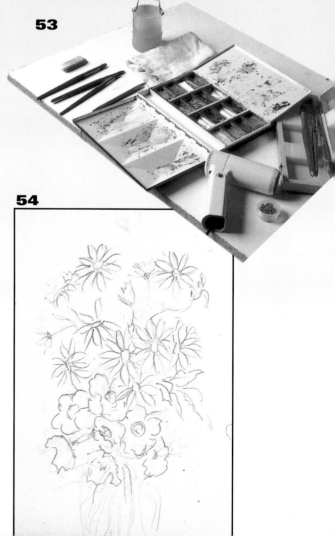

53

54

another way, **Carmen Freixas** follows the three basic rules of the art of interpretation. These are,

Enlarge, Diminish, Eliminate,

which is not the same as **Change.**
She paints the shadows between the flowers in the area of the daisies which she does with ultramarine blue, permanent green and burnt umber (fig. 57). She paints the background with a number 18 sable brush. It is not uniform. On the left she paints with cobalt blue and carmine and then, on the right she paints almost exclusively with cobalt blue. Strangely, in this background, she deliberately leaves small areas of white in which she says she will paint some daisy buds. Once the background is painted and is still wet, she blurs the contours around the flowers. **Carmen** explains that the green of the stems and leaves has to be irregular and never painted in emerald green because it is too strident and dissonant. What she prefers is Hooker green which she sometimes mixes with burnt umber to make it even more muddy.

Now she paints some of the flower stalks at the lower end of the bunch as if they were floating in the air without the jar or vase. *"I do this with some definite marks and later I dilute and spread* (fig. 58). *I will come back to it later to establish these forms"*, says **Carmen** thinking out loud.

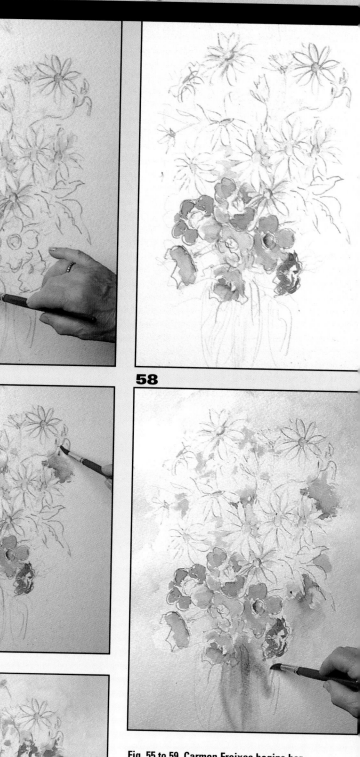

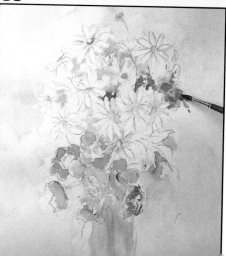

Fig. 55 to 59. Carmen Freixas begins her painting with a few strokes of yellow on the corollas of the daisies, and uses vermilion, cadmium violet and carmine for the anemones (fig. 55 and 56). She paints the shaded area between the flowers, resolving the background with cobalt blue and carmine and paints the stalks dissapearing into the vase leaving the impression of the bouquet floating above.

Painting Flowers: Daisies and Anemones

60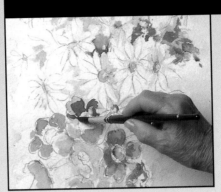

61

The work of **Carmen Freixas** is an exercise in patience. She proceeds with small touches, moving from one side of the picture to the other, diversifying the color, leaving areas and retouching forms with tiny additions, each one being carefully considered and necessary to the whole. For an example of this, look at **Carmen** painting an anemone with carmine which she immediately reduces by using the brush to absorb or intensify by adding more color (figs. 60 and 61). This jumping from one area to another allows **Carmen** to harmonize the colors of her composition, like an image that slowly, bit by bit comes out of the white of the paper. It is important to state, and you will have surely already noticed, that **Carmen** does not test the color before applying it to the picture. She simply mixes and paints without any previous testing. Let me repeat that **Carmen** uses a relatively small water pot and with only a little, almost dirty water which she is not in the habit of changing. As she herself says, this suits her best. This detail is important because generally people work with a larger pot of water.

62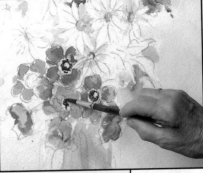

Figs. 60, 61 and 62. Small touches that comprise the painting. Painting and absorption as can be seen in this anemone in figures 60 and 61, or in this figure in which she paints the corollas of the anemones (fig. 62).
Figs. 63 and 64. Carmen paints the daisy buds on the white background at the top (fig. 63). Every now and then she uses her fingertip by pressing on a recently painted spot to eliminate or reduce a color (fig. 64).

There is neither Payne's gray nor black in her pallet. She tells us that she mixes her own blacks with Hooker green and carmine. With this mixture she now paints the corollas of the anemones with a kind of black circles which later, she assures me, when dry she will finish by adding a lighter color to the centers (fig. 62).

The stalk-ends in the lower part of the painting are a lesson in how to paint without absolute clarity but explaining the forms in a way that is more decorative than realistic.

Carmen now marks out forms with her Hooker green. She returns to the upper area drawing and painting the daisy buds and then sorting out some background colors between the flowers. Finally she paints the inside of the corollas with a clear wash of green and carmine mixed with burnt umber (fig. 63).

She continues painting and finishing off forms with a constant vibration of the hand and brush, with infinite and multiple touches of color and in a constant state of nervous activity. She alternates this with short pauses for reflection in which she looks at the work from a certain distance, checking its progress.

63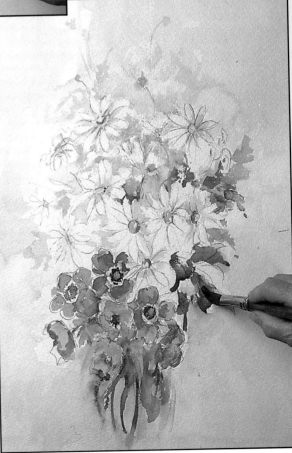

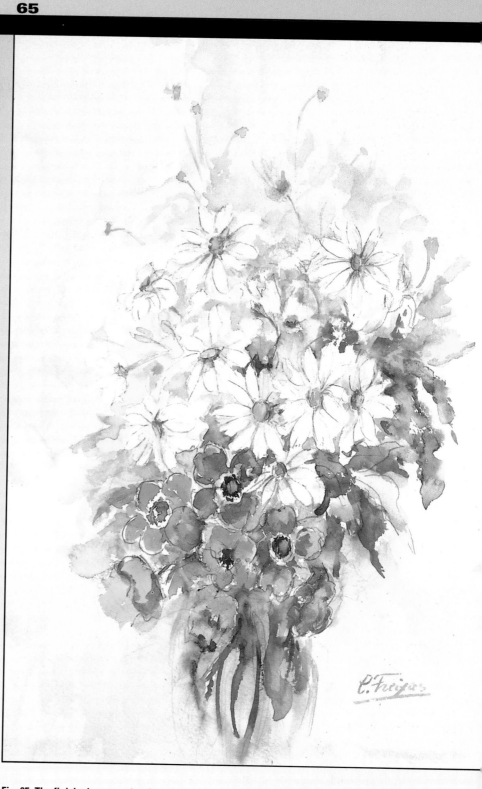

Now, after applying a small touch of color underneath a daisy, **Carmen** squashes and dilutes this color with the tip of her middle finger (fig. 64). **Carmen** has used this technique of using her middle or index fingers many times in the course of this painting. Now that she is in the final phases of the work she works more slowly, thinking over every brush stroke, stopping now and then to distance herself from the easel in order to observe and evaluate the evolution of the composition. During this last phase **Carmen** rubs out some pencil marks with an eraser. She signs it and leaves it as it is so as not to fall into the temptation of returning and retouching. "This final stage of the watercolor", I say to **Carmen**, "when one is in doubt whether or not to continue, you should remember the anecdote that that wonderful and famous artist, **Federico Lloveras,** used to tell: *Leave it alone; or Fortuny's hand will come down from heaven and pull the brush from your hand so you cannot continue painting what is already done and what is well done!*".

Fig. 65. The finished watercolor. Carmen Freixas continued touching and retouching in silence and increasingly more and more slowly, looking at the painting and then stepping back and coming nearer again to have another look. She could have left it like that. And so she did so by signing the picture, which deserves a better frame. This confirms Carmen Freixas' talent and fame as a watercolorist.

Painting an Urban Landscape

66

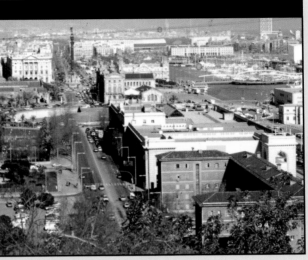

Gaspar Romero is going to paint a watercolor of an urban landscape, a view of Barcelona's, well, actually a view of Barcelona's port and the surrounding area, to be more precise. The subject, as you can see from the adjoining photo (fig. 66), is based on a parallel perspective of only one vanishing point, and with a very high horizon line. That is because this picture was taken from the top of a nearby mountain called Montjuïch, from a place commonly known as Miramar near the TV studios.

Gaspar is going to paint on an English brand of paper, Laughton, on which he draws the view first with a 2B pencil and then as is his habit, he paints the shadows in a mixture of cobalt blue and ultramarine. This blue, as you can see in figure 67, is very light, very diluted. It is a faintly perceptible wash but sufficient for laying out the forms and completing the drawing. This formula of painting the shadows in pale blue facilitates the structure and placement of the composition from the motif, and it also immobilizes the form of the shadows thus avoiding the light changes that occur when one is painting the same subject for two or three hours.

But **Gaspar Romero** has already begun to paint, "from top to bottom and from left to right", as he tends to do and with even more reason to do so in this case because in order to repre-

67

Figs. 66 and 67. The subject, Barcelona port and surroundings seen from the mountain of Montjuïch. In figure 67, the completed drawing by Gaspar Romero with the addition of a sharp light blue with which he paints the shadows which will not change during the time it takes him to finish the painting.

sent this aerial perspective, it is necessary to paint from less to more. So he begins the painting with the houses and forms in the background which he paints with cobalt blue and a spot of carmine. And then he resolves that portion of ground in the background on the left with English red. He paints the trees situated immediately below with permanent green and ochre (figs. 68 and 69).

For those first touches he employed a size 12 mixed sable and synthetic brush and now he is working with a number 6 sable brush which he alternates with a tiny flat brush for the more concrete forms. He uses the brush to trace the hard edges of the lines of the windows and shadows etc. (fig. 70).

68

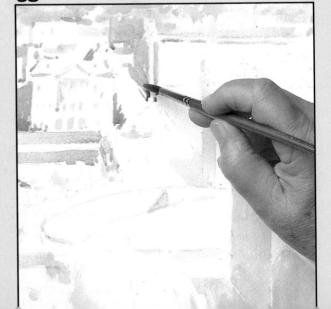

Gaspar does not use rags for absorbing color but he always holds a folded piece of absorbent paper in his left hand instead, as if it were a small sponge.

Now he paints the middle ground. He paints the sea to which he adds a ferry, another boat and sorts out buildings, windows, rooftops, shadows and green areas. He stays within this bluish coloration which is ideal for middle and backgrounds (fig. 71)

Now he paints the shadows on the nearer buildings which are also bluish in tone, using a mixture of cobalt blue and carmine. **Gaspar** does not overlook the aerial perspective and if you look at the shadows on the buildings you will see that the nearest are the darkest (figs. 72 and 73). Observe that in figure 73 he has not only resolved the small details of the terraces but he applies a very light, cream wash to the side of the house with the darkest blue shadow.

It is a watercolor of hues, tones, shades and of different colors such as the autumnal colors of the tree in front of the biggest building (fig. 72), or the nearest red house on the next page which he resolved with a very light wash so that the subsequent colors do not lie on a perfectly white ground (fig. 74).

69

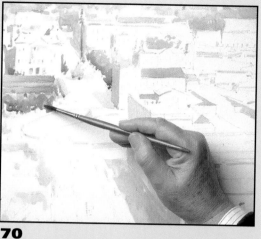

70

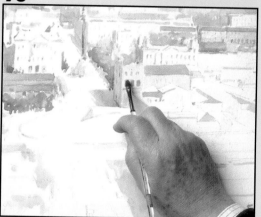

Figs. 68, 69 and 70. Gaspar begins to paint "from the top to the bottom", the houses and forms in the background, the lines of the terraces and the window openings.

Fig. 71. Now he paints the sea and adds a boat and a ferry. Then he works on the buildings, rooftops, ledges and terraces.

Figs. 72 and 73. He paints the bluish shadows of the nearest buildings, darkening the nearest shadow to represent the atmospheric or aerial perspective. This dark shadow contrasts with the lightest, furthest away shadow.

71

72

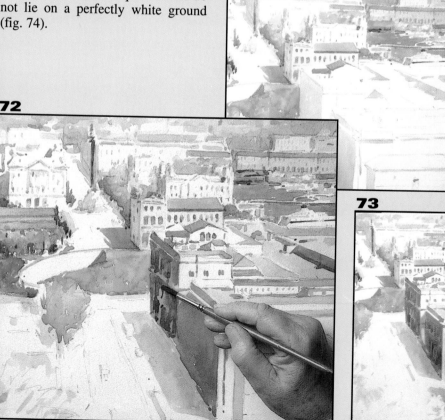

73

Painting an Urban Landscape

This is a difficult subject but **Gaspar** is an excellent draughtsman and so he can draw thick or thin lines at a whim, without a ruler as in the painting of the rooftop of the red house in the shade (figs. 75 and 76) or as in the case of the drawing and painting the gray of the asphalt in Payne's gray and ultramarine blue from the distant part of the avenue to the foreground, conserving this white strip in the center of the road (fig. 77). Further examples of his dexterity and control can be seen in the painting of the shade from the two nearest buildings, and also the painting of the vehicles and their shadows on the ground (fig. 78). Notice also, in figure 78, the blue shadow of the nearest building. **Gaspar** has lifted off a thin strip which is curved and vertical in the upper area corresponding to the posts of the two lamp posts.

74
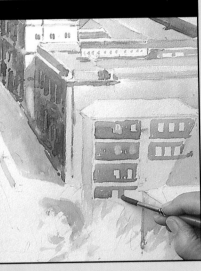

75

77
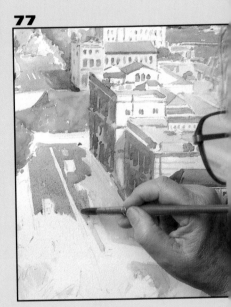

76
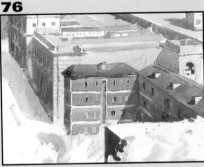

Figs. 74, 75, 76, 77 and 78. His perfect control in the art of drawing and of watercolor painting allows Gaspar Romero to draw lines and forms at will with only the paint brush or pencil, with such conviction and control that the result looks as if it has been done with a ruler. This can be seen in the painting of the red house in the foreground (fig. 74) or the rooftop of this same house (figs. 75 and 76), or when he draws freehand, the gray area of the asphalt but keeping the white area in the center (fig. 77), or the shadow created by the nearest buildings and the vehicles and their shadows (fig. 78). See also in this figure the white strips created by Gaspar that represent the street lights.

78
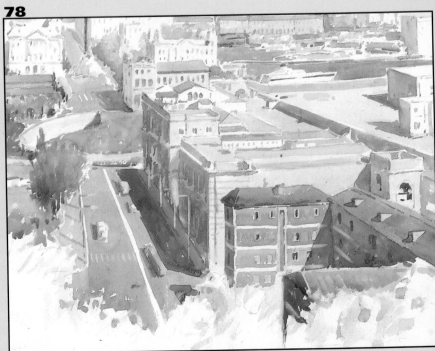

But our guest is getting to the end of his task. He paints the trees in the foreground. On the left, a luminous, permanent green; in the center, ochre with a speck of permanent green; on the right, a somewhat dirty green (fig. 79). In the next illustration, number 80, **Gaspar Romero** adds a darker color to model the form of the trees. In figure number 81 you can see the finished work signed by this magnificent watercolor artist, **Gaspar Romero.**

Figs. 79, 80 and 81. Here Gaspar paints the trees in the foreground. First he paints the light areas with a light green wash, then, with a darker wash he paints the shady areas. In figure number 81 we have the finished work; a good example of drawing, of color and of perspective.

79

80

81

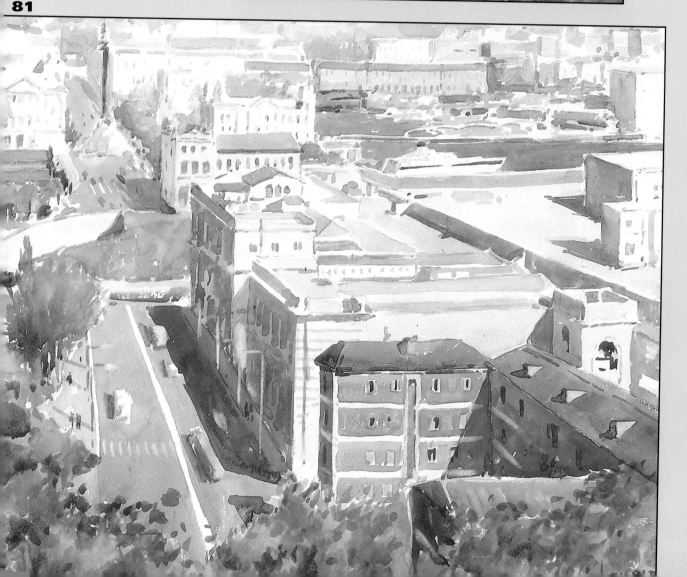

Painting an Interior in Watercolors

82

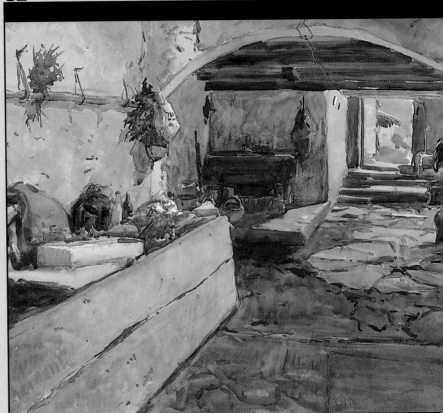

One day, as **Gaspar Romero** is a good friend of mine, I went to his house and we began to look at folders of watercolors. I soon saw a watercolor of an interior that was an exceptional example of its kind (fig. 82). I asked him if we could go to this place and make a record of the painting process of this scene. "Oh, no! Impossible! It has been in ruins for a long time now. It was an old windmill but they have long since demolished it". I then thought that **Gaspar** could repaint the scene by making a copy of the original. **Gaspar** agreed. A few days later we were in **Paco** the photographer's house, **Gaspar** drawing and painting, and I taking these notes.

I began to make notes. **Gaspar** uses a box pallet with creamy watercolors. He paints on thick Fabriano paper, 50 x 40 cm and of a weight of 300 grams. He uses three sable brushes of sizes 8, 12 and 14 and a flat brush of 5 cm. Also the ever present roll of absorbent paper and pieces of it ready for use.

With a 2B lead pencil he begins to draw the subject. Now and then he controls the perspective by searching for the point of coincidence at a determinate point (the vanishing point) of the lines perpendicular to the horizon. He verifies this by eye. And he finishes with the drawing which is completely lineal, without shadows, which is just how a drawing for watercoloring should be.

83

84

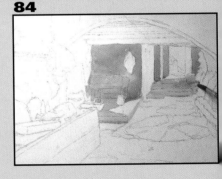

85

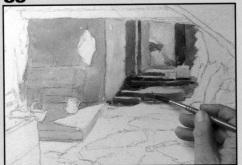

Fig. 82. This is the subject; the watercolor Gaspar painted many years ago of the windmill which is now in ruins and for this reason there is no photograph of it here. That is why he agreed to copy the original painting.

Figs. 83, 84 and 85. The drawing and the first steps of the painting which he began starting with the background, with the doorway, the steps and the light green wall. He also worked on the shadows.

And so he begins the painting at the most distant point, that is, the door that appears on the right of the composition. He paints the outline of the door in soft, regular washes of color, adjusting the local color from the model from the outset. He uses yellow ochre for the door frame and the steps, permanent green for the light coloured wall and burnt umber and violet (cobalt blue and cadmium red) for the shady areas (figs. 84 and 85). **Gaspar** uses a separate paper for testing the colors before applying them to the painting.

Straight after that he paints the forms of the facing wall and the steps in the background and having resolved the background of the room (fig. 86), he takes a large size 12 brush loaded with color and paints the beams that cross the ceiling, first with a coat of ochre and sepia and then he draws the beams with a mixture of burnt sienna. The beams are highlighted by more intense parallel lines. He holds the brush firmly to create clearly defined borders, as can be seen in figure 87.

He now moves on to the floor. First he dampens the area using the 5 cm flat brush. He then makes a mixture of cadmium red and cobalt blue and paints starting at the top and working down, with a number 14 brush (figs. 88 and 89). With a wash that is darker than the interior he deals with the irregularities and bumps of the floor due to the light that shines from the back, through the door and across the floor.

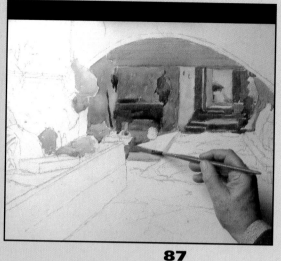

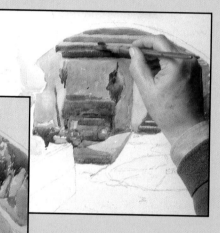

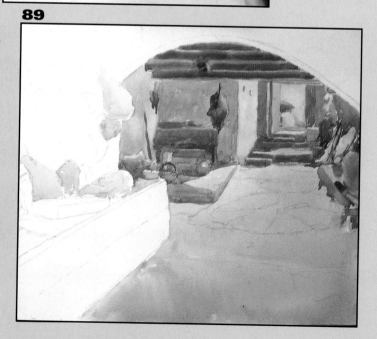

Figs. 86 and 87. The forms of the walls and the distant steps are resolved and he paints the beams which he highlights with brush strokes of intense color.

Figs. 88 and 89. He dampens the floor area of the room with the 5 cm flat brush and then paints on it with a number 14 brush.

Painting an Interior in Watercolors

90 **91**

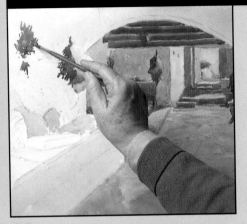

With a number 8 brush and with denser paint he begins to paint the dried plants which hang from the wall. Payne's gray and emerald green for these branches. While this branch is still wet he uses a cleaned brush to absorb excess water and color in such a way that the action of the brush forms and models the forms of the dried leaves (fig. 90). **Gaspar Romero** considers it necessary to intensify some of the coats of previously applied color with new touches of violet. With a new coat of Prussian blue and Payne's gray he intensifies the upper area of the arch in order to produce a darker, more intense tone (fig. 91).

With a number 8 sable brush **Gaspar Romero** now resolves the objects on the table on the left with small touches of color. To reproduce these objects accurately he paints from the general to the detail, painting the form and volume of the bottle, the rags, the boxes and other utensils, highlighting the details (fig. 92).

The painting is now in its last stages. **Gaspar** retouches and adds diverse colors and forms. He goes back again, superimposing new washes over the old ones until he creates the desired tone, concentrating on the wooden boards on the left and the arch above (figs. 93 and 94). But he does not only add color but he also rectifies and reduces the tone of some of the shadows and thus achieves more contrast between the different elements that comprise the picture.

Finally he leaves it and signs in the corner. "Do you like it?", he asks me. "Of course I do. You have achieved an excellent copy and a good example of drawing, of perspective and harmony of color with this splendid range of ochres, greens, umbers and pinks which co-exist under this dominant violet. I like it, Gaspar. I offer you my sincere congratulations!".

92 **93**

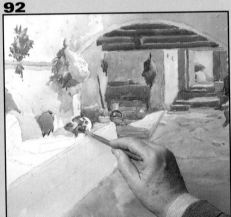

94

Figs. 90 to 95. The direction of the light, the back lighting determines of the shadows throughout the interior but above all, the details of the floor. Also he resolves the form and values of the dried bunches that hang from the wall. This lighting also causes an intensification of the color on the upper part of the arch (fig. 91), and also the small objects on the table (fig. 92). And lastly by adding color he intensifies the color of the boards in the foreground. In general he accentuates the form and color (figs. 93 and 94). He then signs and so the work is finished (fig. 95).

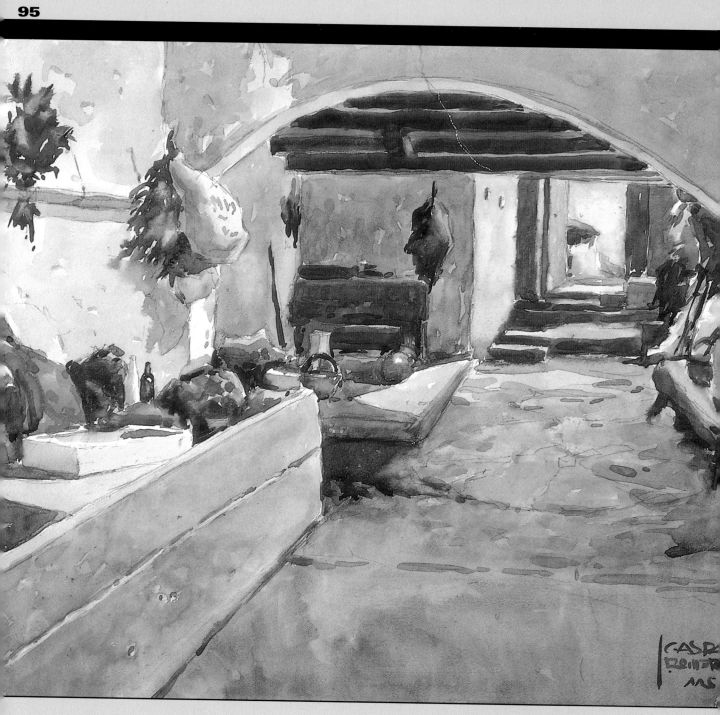

The Vanishing Point of Diagonals

96

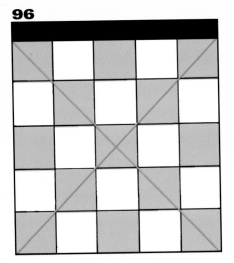

In the volume on *Composition and Interpretation* from this collection there is an introduction to the fundamental rules of perspective in which there is a brief explanation of what the horizon line, the vanishing points and parallel and oblique perspective are. To supplement this information we are now going to have another look at the vanishing point for diagonal lines from which it is possible to draw mosaics, rows of trees, columns and stairs. These instructions are here and on the following pages. We will start by looking at the method behind drawing the vanishing point of diagonal lines for representing geometrical forms which repeat in the distance and vanish towards the horizon.

In figure 96, you can see a mosaic as seen from above. Notice that the two diagonal lines that cross the squares form angles of 45°. In figure 97 we can see the same mosaic in perspective. For this we have to lift up the picture plane which in fact is nothing more than the paper on which you are working. Now check that the diagonal lines in the 45° angle that we saw in figure 96 of a mosaic seen from above, are repeated in perspective here, at a 45° angle in respect to the vertical parallels. They go to the vanishing point and determine the perspective of the mosaic.

Now it is only necessary to explain at what distance the ends of the diagonals should be placed on the horizon line in relation to the central vanishing point. You will see that on the horizon line, on both sides of the vanishing point (VP), and at a distance equal to three times (A, B, and C) half of the width of the picture plane (figs. 97 and 98).

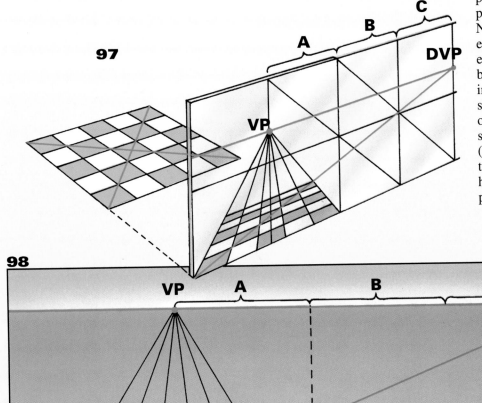

Figs. 96, 97 and 98. Diagrams of the vanishing point of diagonals showing a mosaic seen from above (fig. 96), and the same mosaic in perspective, determining the position of the vanishing point of diagonals (figs 97 and 98). Read the adjoining text for a better understanding of the subject.

Drawing a Mosaic in Parallel Perspective

First decide on the height or level of the horizon line (HL). Divide the bottom of the mosaic into six equal parts at the earth line (EL). Draw the lines that vanish at the vanishing point and draw by eye, in the lower right corner, a square in perspective by including two spaces next to each other (fig. 99).

Draw a diagonal that crosses the verticals of the square grid and the rest of the mosaic. The points of intersection with the vani-

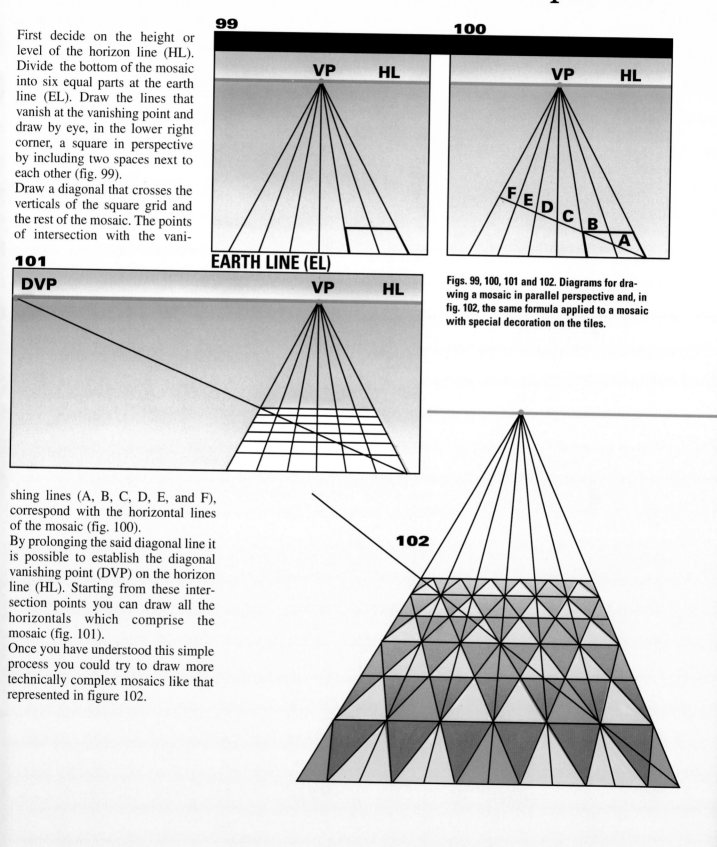

Figs. 99, 100, 101 and 102. Diagrams for drawing a mosaic in parallel perspective and, in fig. 102, the same formula applied to a mosaic with special decoration on the tiles.

shing lines (A, B, C, D, E, and F), correspond with the horizontal lines of the mosaic (fig. 100).

By prolonging the said diagonal line it is possible to establish the diagonal vanishing point (DVP) on the horizon line (HL). Starting from these intersection points you can draw all the horizontals which comprise the mosaic (fig. 101).

Once you have understood this simple process you could try to draw more technically complex mosaics like that represented in figure 102.

Drawing a Mosaic in Oblique Perspective

Draw the horizon line (HL), and the vanishing points (VP1 and VP2). From these, construct the square in oblique perspective. Draw a vertical line to the horizontal line from the nearest vertex of the square and so creating the measuring point (MP). Then draw the earth line (EL). Draw the diagonal A, which, passing through the vertex A', joins the measuring point (MP) with the point that marks the length of the earth line. Divide the earth line into five and trace the diagonals (A, B, C, D and E) which will vanish at the measuring point (MP) (fig. 103).

You will now have, on the left hand side of the square grid, a series of points which you can connect with vanishing point 2 (VP2). Then draw a diagonal from the nearest vertex of the square (F) to the most distant one (J). By continuing this line to the to the horizon line you will find the diagonal vanishing point (DVP) (fig. 104).

When this line crosses the lines that vanish at vanishing point 2, it determines the diagonal points (F, G, H, and I etc.). From these points draw another series of diagonal lines which will join up at vanishing point 1 (VP1) (fig. 105).

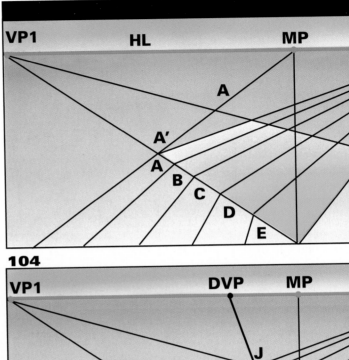

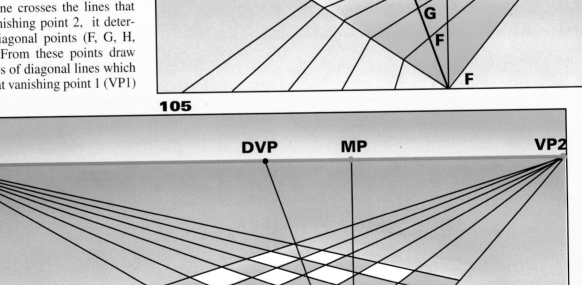

Figs. 103, 104 and 105. Diagram for drawing a mosaic in oblique perspective (read the adjoining notes).

How to Divide Depth

In order to paint a row of trees or columns in perspective (figs. 106 and 107), follow this simple formula. First draw a rectangle in perspective which corresponds to the total space occupied by the row of trees or columns. Locate the nearest vertical of the rectangle in perspective and divide it in half (point A), then trace a line to the vanishing point (VP) on the horizon line (fig. 108). Then calculate by eye the distance that lies between the first and second space and draw a vertical, as can be seen in figure 109. Now draw a diagonal, starting from vertex A, which passes through center B and determines the position of point C (fig. 110). This point C allows you to draw a second vertical corresponding with the third tree or column and continue successively until the end (fig. 111). You can check the exactness of the calculation by lengthening the diagonal lines to a second vanishing point on a vertical horizon line (fig. 112).

The other formula allows you to divide depth by eye, without any previous calculations. Consider the division of spaces within the space A-B (fig. 113). We begin by drawing an earth line, a horizontal from the nearest vertex (C), and we situate the measuring point at the point where the horizon line crosses the nearest vertical of the rectangle. Now we draw a diagonal from the measuring point to the earth line, passing through the vertex of rectangle E. This allows

106

107

108

VP

109

A

110

A

B

C

111

112

113

VP

A ⟵ - - - - - - - ⟶ B

MP

E

C

EARTH LINE

us to divide the earth line into as many spaces as exist in the model (fig. 113). Now by drawing diagonals from the measuring point to the earth line we will achieve the automatic division of spaces in perspective (fig. 114).

114

MEASURING POINT

E

C

VHL

Parallel and Oblique Perspectives of a Staircase

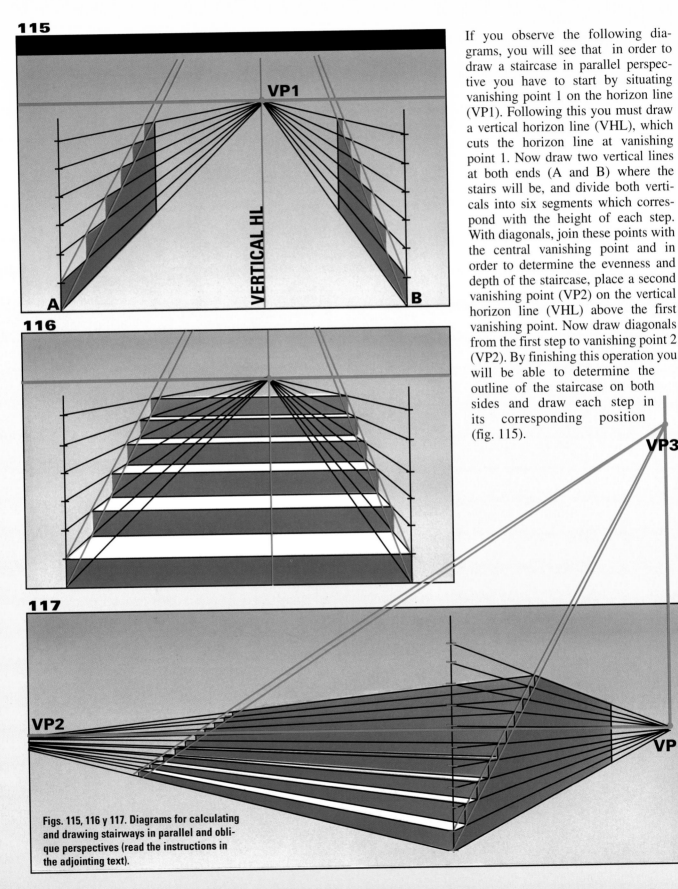

115

VP1

VERTICAL HL

A **B**

116

117

VP2

VP1

VP3

If you observe the following diagrams, you will see that in order to draw a staircase in parallel perspective you have to start by situating vanishing point 1 on the horizon line (VP1). Following this you must draw a vertical horizon line (VHL), which cuts the horizon line at vanishing point 1. Now draw two vertical lines at both ends (A and B) where the stairs will be, and divide both verticals into six segments which correspond with the height of each step. With diagonals, join these points with the central vanishing point and in order to determine the evenness and depth of the staircase, place a second vanishing point (VP2) on the vertical horizon line (VHL) above the first vanishing point. Now draw diagonals from the first step to vanishing point 2 (VP2). By finishing this operation you will be able to determine the outline of the staircase on both sides and draw each step in its corresponding position (fig. 115).

Figs. 115, 116 y 117. Diagrams for calculating and drawing stairways in parallel and oblique perspectives (read the instructions in the adjoining text).

118

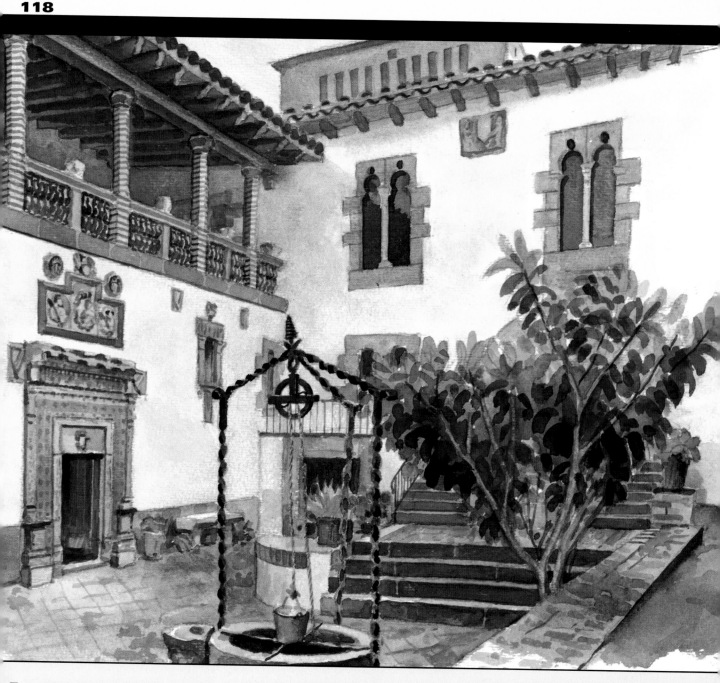

To conclude this exercise all you have to do is draw the parallel horizontals that define the steps and thus giving us the final form of the staircase in parallel perspective (fig 116).

The process for oblique perspective is similar but you have to add a third vanishing point (VP3) on the left or right side of the stairs depending on the position of the observer in relation to the subject. Also, if you look at figure 117, you will notice another important difference. There is only one vertical for determining the height of the steps which is situated in the vertex of the vanishing lines.

Fig. 118. Here we have the image of a patio painted in watercolors by Jordi Segú in which we can see various aspects of the rules of perspective that we have looked at in the last few pages. In the first place, the construction and the angle of vision are a clear example of oblique perspective with two vanishing points. The terrace and the columns on the first floor were drawn by calculating the division of the spaces and depth. The doorway beneath the terrace in the left hand wall and the windows on the facing wall made it necessary for Jordi Segú to calculate the central perspective of both openings. And then there is the stairway, which is not very visible, but which also presents a problem of oblique perspective such as the one we have looked at here. Jordi Segú carried out the drawing of this subject by eye but he knows full well how to do it and what to do to solve all these problems of perspective.

The Technique of Sketching Step-by-Step

In the art of drawing and painting it is quite normal practice to make notes, sketches or plan projects which later may be turned into definitive paintings.

For this reason **Pablo Picasso**'s sketch books are famous. Some are pocket sized like the one we can see in figure 119 in which **Picasso**, apart from sketching figures, sometimes chose animals such as dogs, made shopping lists or worked out his personal accounts in them. But **Picasso**, like all artists, drew in his sketch book as an exercise and in order to save up references that he could consult later for his paintings.

Van Gogh talked about keeping a sketch book when he said: *"Making studies according to how I feel is like sowing seeds, it is making pictures"*. And **Monet** when he wrote to his second wife from a sea expedition said *"I am very happy to be here and I will surely return with a large quantity of sketches from which to do great things at home"*.

The great advantage of sketching is that the artist works without being afraid, without worrying about the finished product. A sketch is always a rehearsal, a watercolor that one is prepared to tear up or throw away. So with this attitude the artist works more freely, more spontaneously. He knows that he is not playing his last card and that it is possible to rectify it or start again which is not the case with a definitive watercolor.

See on this and the next page some examples of sketches made by **Mercedes Romero** who is a qualified artist and art lecturer. Notice how **Mercedes** —Merche to us—, confirms this idea of freedom.

119

Fig. 119. Here we have one of Picasso's small sketchbooks. It is pocket-sized and we can see a sketch of a girl drawn with coloured pencils.

120

121

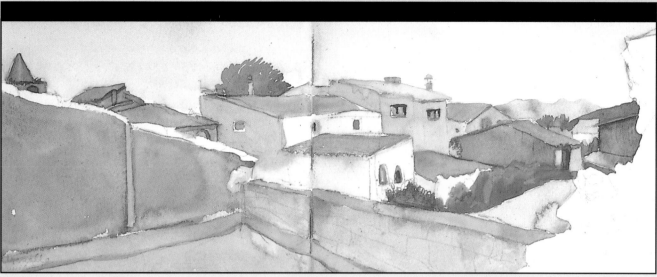

122

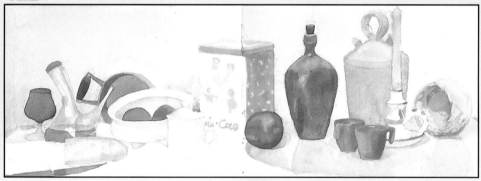

123

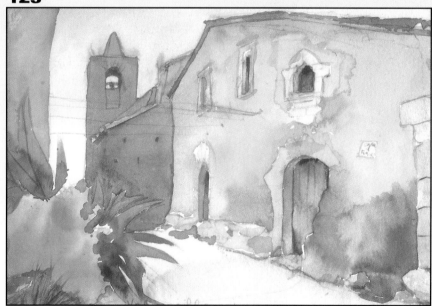

By the way she draws and paints for herself, like a rehearsal in order to practice and learn. So there is a freshness, a feeling of improvisation, resolved in a spontaneous way which shows her command of the art of sketching.

Figs. 120 and 123. Mercedes Romero. A collection of sketches. At home or out, the art lecturer Mercedes Romero always carries her 10 x 15 cm sketch book with her. In it she paints the first thing that presents itself or which calls her attention. Figures, still lifes, landscapes and even the cat if the occasion arises.

The Technique of Sketching Step-by-Step

The sketch is a study done before doing the painting. It is an outline from which we determine the final layout, the best composition, the best contrasts and the best color harmonies. It is quite normal for the artist to carry out various studies of this kind and of course the final painting is based on the most complete sketch. From this sketch the artist paints the picture in the studio like **Monet** used to do, with the advantage that these days it is always possible to take a photo of the motif and use this also. This is a method that I sometimes use myself.

The problem of sketching is fundamentally one of drawing. As the sketch demands a quick resolution, a thorough grasp of the art of drawing is necessary because as you already know, painting watercolors means drawing and painting at the same time.

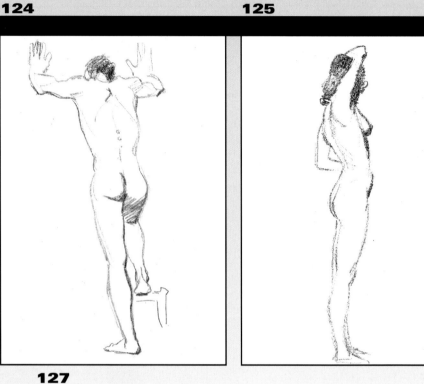

124

125

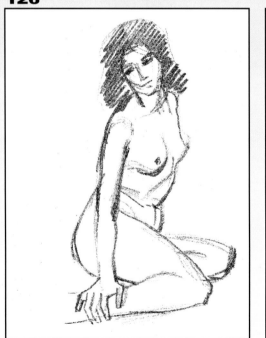

126

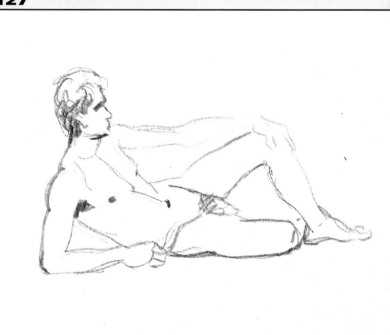

127

In order to improve your painting of sketches I recommend that you yourself set a time limit for each attempt starting with perhaps half an hour and gradually reducing the time to say, fifteen minutes. This is what expert artists do when they attend group activities or club meetings and draw from the model. The model may be dressed or nude and the sessions may be of a couple of hours or a few days with the same pose. In other sessions the

Figs. 124 to 127. Here we have four sketches of the nude figure drawn by Jordi Segú done in sessions of poses of five minutes. This is record time for resolving the dimensions and proportions of the figure which in this case, as he explained to me, obliged him to draw in a continuous line without lifting the pencil from the paper.

model may change the pose every few minutes which obliges the artist to capture the dimensions and proportions of the human figure which is the most difficult subject to draw in a limited time. You will see in the adjoining figures 124 to 127 some of these sketches drawn by **Jordi Segú**. *"They are sketches done in five minutes maximum. You have to acquire a certain experience"*, he explains, *"in drawing only in lines and by beginning at the top you work down to the body, legs and feet without lifting the pencil off the paper"*.

And so with this same technique **Jordi Segú** painted the series of watercolor sketches that we can see on pages 47, 48, and 49 (figs 128 to 136). In the first step he resolves the drawing in a schematic way and starts painting with some color stains. In the next step he completes and makes the forms more decisive and in the third stage he clarifies the forms, contrasts and color. He painted and resolved these sketches using a thick, number 14 sable brush throughout, in order not to enter into details and to resolve the sketch using his best technique. He also tried to make a synthesis of form and color with touches of one coat only.

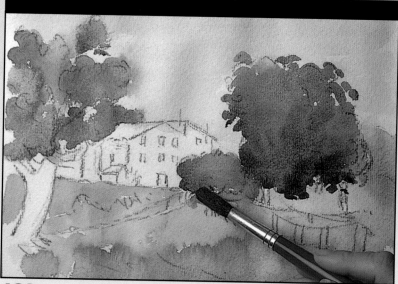

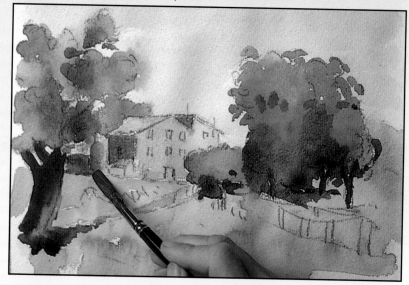

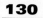

Figs. 128, 129 and 130. A step-by-step development of a watercolor sketch by Jordi Segú. One must appreciate the short execution time which results in a spontaneous finish through a synthesis of form and color.

The Technique of Sketching Step-by-Step

131

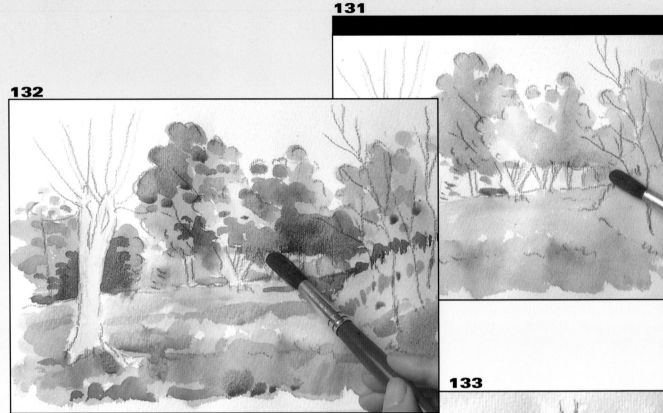

132

133

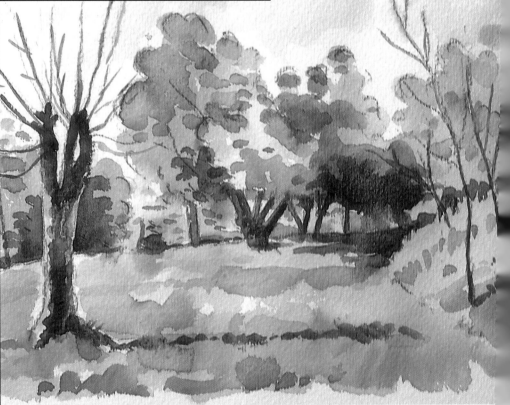

Figs 131, 132 and 133. Jordi Segú begins the outline (fig. 131) with a schematic drawing in which he has only used a few lines to situate the tree trunks and branches. This is sufficient to begin to paint because the canopies and groups of leaves have to be resolved in a synthesis of only color. He then iniciates the watercolor with a tenuous wash, almost without color but with a diversification of hues. In figure 132 he paints the canopies of the trees and the forms and colors of the grass and earth with some very precious and spontaneous touches which will remain in the finished work. The finished work (fig. 133), shows the contrast of the tree in the foreground on the left and a few more touches which explain the presence of trunks, shadows and more trees. Take note of the coloring with a clear tendency towards grayish and dirty tones.

134

135

136

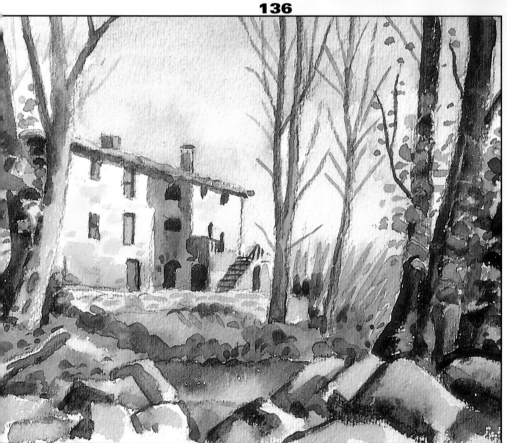

Figs. 134, 135 and 136. The third sketch. The drawing is more defined and shows the tree trunks and branches and the shape of the house (fig. 134). In this first stage Segú painted the sky and some forms in the foreground. But notice the detail of the painting of the groups of leaves. Greens to the left, ochre and English red on the right. With these touches of color Segú has created reserved areas where, as you can see in the second stage (fig 135), he paints the darker color of the trunks but reserves the light color of the groups of leaves. Segú paints in a darker green in the middle ground and for the reeds between the house and the trees. For the house he has used a lighter color and he has painted the shadow across the center with violet. In the finished sketch (fig. 136) Segú has finished the house and the stones in the foreground. He has painted the trees in the middle ground and also the groups of leaves.

Painting a Seascape Step-by-Step

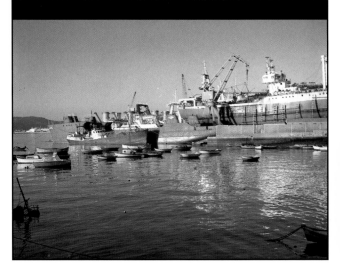

137

I went to paint in Vigo. Vigo is in the Northwest of Spain, just above Portugal and is in the land of estuaries and sailors, oysters and spider crabs. I went to the sea looking for something to paint which I finally found outside the port at an anchorage point with various ships and small boats anchored there. It was a very complex subject as you can see from figure 137. But it occurred to me that I could cut out the group of small boats and concentrate on the elements that really caught my attention; the marine blue sea in the foreground contrasting with these red and golden reflections. Also the boats with this orange range of colours and reds, yellows, grays and whites offering a contrast of brilliant complementary colors against the blue of the sea. A subject worth painting and which reminds me of **Paul Cézanne** when he said,

**"Contrasts and relationships
between tones and colors:
that is where the entire secret
of painting lies".**

So I began the process of interpretation by looking at the subject and trying to apply the three terms that describe the synthesis the art of interpretation:

increase, reduce, delete.

Yes, one has to darken the sky, I said to myself, to increase the contrast of the white elements of the boats. I will have to mask these whites and reflections with liquid eraser. I will also have to intensify the blue of the sea to dramatize the golden reflections. And finally, I will have to omit those small boats and add the reflections of the ships on the left hand side.

With these ideas in mind I begin to draw with a 2B pencil beginning with a centralized cross to help with the calculations of dimensions and proportions (fig. 138). I immediately apply the liquid eraser to mask the poles and forms against the sky and also the reflections on the sea (fig. 139). And I paint the sky darker above the horizon with a mixture of ultramarine blue and carmine. I then begin on the ships. First the one on the left with light English red and a mixture of the sky color in the darker areas. After I paint the dark band on the right with a reserve on this white fringe which I reserve directly. I resolve the dark strip with English red and a little Prussian

138

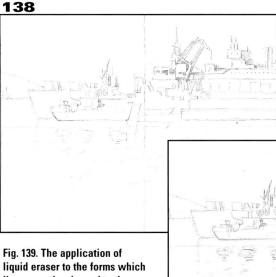

Figs. 137 and 138. The subject. An anchorage in Vigo in the north west of Spain with big ships and small boats (fig. 137), and the initial drawing with the usual central cross (fig. 138).

139

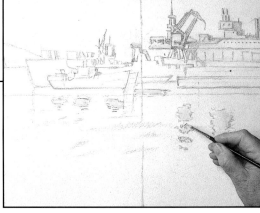

Fig. 139. The application of liquid eraser to the forms which lie across the sky and to the reflections and bright spots on the sea.

Fig. 140. Painting the sky and the first colors of the ships.

140

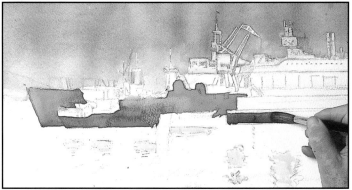

blue (fig. 140). I paint the two gray strips with the darker wider one on top of the lighter one but before this I mask with liquid eraser (also called latex) for those poles in front of the wide, gray strip. And without further ado I begin on the sea. First with a general light wash made of cobalt and ultramarine blues and quite a lot of water (fig. 141). Then, with the drawing board upside down, I paint a graded wash of intense blue, made up of Prussian and ultramarine blues and making it more intense below (fig. 142).

Now I return to the ships by painting some details and generally filling out the forms (fig. 143). But before this I made the mistake of removing the liquid eraser and now I also notice that the sky is not sufficiently dark enough to highlight and contrast the poles and forms that lie against the sky. So I have to replace the liquid eraser over some of these elements, paint the sky darker and then rub out the liquid eraser again. I continue with the yellow of the cranes and also the portholes and shadows and finally get to the stage that you can see in figure 144.

Fig. 141. I paint the two gray strips and a first coat of light blue for the sea.

Fig. 142. I continue on the sea with the board upside down, with a color gradation from dark to light blue.

Fig. 143. I make the mistake of eliminating the liquid eraser without previously darkening the sky.

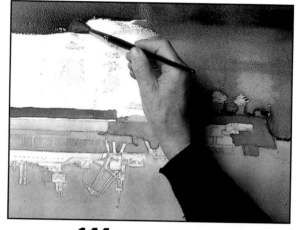

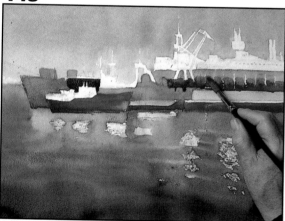

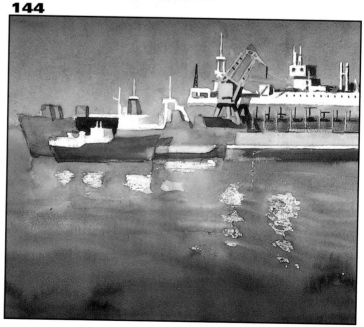

Fig. 144. The mistake corrected with a new application of liquid eraser in order to darken the sky and I paint details on the ships on the right.

Painting a Seascape Step-by-Step

145

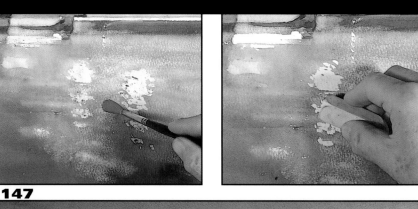

146

147

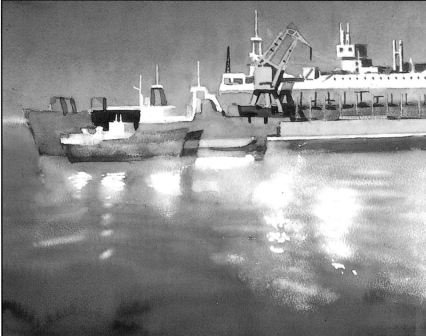

Following this I begin the work of absorbing and reducing the color of the sea underneath the boat on the right and around the reflections on the same side. First, I tried this with a sable brush and retouching with absorbent paper but with such a poor result that I then applied neat bleach. I applied it to these areas over and over again with a synthetic brush and then re-absorbed with absorbent paper. It is boring and monotonous work but I finally got the result I wanted which you can see for yourself in figure 145 in comparison with the fragment in figure 144.

I then eliminated the liquid eraser that was left on the reflections on the sea with a typical eraser (fig. 146) and continued working on the whites and reducing colors with bleach, the synthetic brush and the absorbent paper around the bright areas. See now the final result of this complicated operation with the addition of various small highlights. Notice these three horizontal bands on the right of and above the big intense areas achieved by this technique of creating whites with bleach (fig 147).

The color, the reddish color reflected on the water around the boats on the right and center (fig. 148). And finally the sea! The ripples in the bands of blue are made from Prussian and ultramarine blue.

Figs. 145, 146 and 147. I lighten the areas around the white spots with liquid eraser and reducing the intensity with bleach by lightly stroking the area with a synthetic brush and then by the use of absorbent paper (fig. 145). I then eliminate the liquid eraser (fig. 146) and work on creating whites until I get the result in figure 147.

Figs 148 and 149. The application of color in the reflections. Orange reds and dark cadmium yellow. In figure 149 I first created a white then painted this red stain which later disappears or is reduced to small flecks of color in the finished watercolor.

148

149

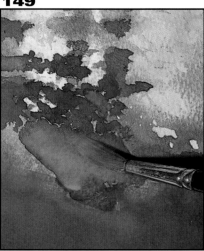

150

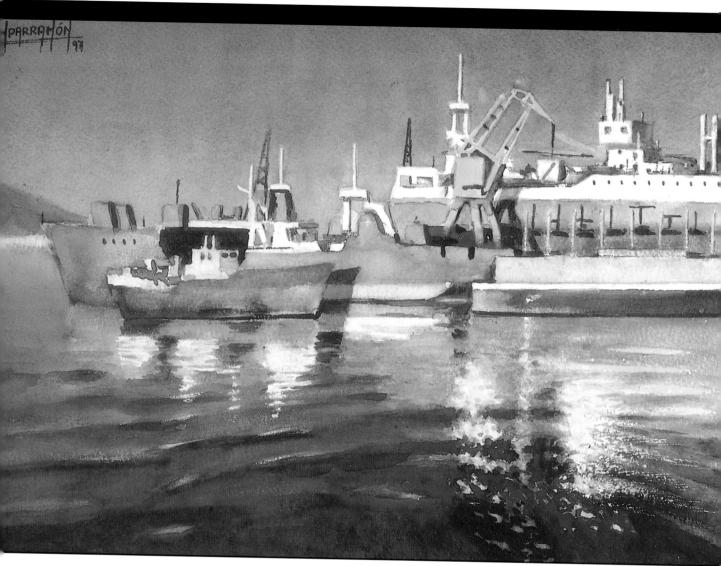

It is an intense, dark marine blue applied from left to right along the waves and curving slightly up. I reserved the small dots, the small bright areas of reflections, which are quickly blended into the light blue of the waves of the last stage. In the finished watercolor (fig. 150), you can see the lengthening of the blue waves towards the middle, the painting in of dark cadmium yellow and abundant water on the big reflections which include these bright horizontal bands in the top right hand side. There is a red stain (fig. 149) which correctly retouched, appears in the final work as a group of small dots of red light reflected on the sea.

So there we have the finished watercolor of the anchorage and a number of boats at berth in Vigo. It was necessary in the last general revision to make the area of reflection on the right bigger. This I did by creating whites with a cutter and painting over them in dark cadmium yellow. I also retouched some of the colors like the mountain in the background on the left for example. I repainted it and so absorbed the original color and tones which produced excessive contrast. I softened some of the shapes and, satisfied with the result, I signed.

Fig. 150. The finished watercolor after a lot of time spent retouching elements. The most significant is the elongation of the yellow reflection on the right hand side of the sea created by a laborious process of creating whites with a cutter which were later painted with dark cadmium yellow. And many other small things such as the softening, with a thin coat of very light grayish ochre, of all the white elements across the sky. The reduction of some shadows on the yellow crane, the intensification of the shadow on the small boat on the left, the painting of the hill in the background and the creation of whites and small touches of color on the sea. I finally took the drastic measure of cutting 2 cm off the bottom of the composition. I think this was necessary and I think it works better like that. Two days later I signed it.

Painting a Still Life in a Cold Color Range

151

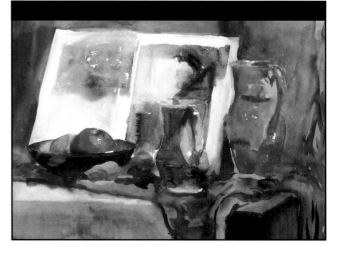

We are in the photography studio belonging **Paco Vila Massip** with **Antón Martín** the famous watercolorist and art lecturer at the Catalonian Watercolorists Association. Here he is responsible for teaching over a hundred pupils, morning and evening and with groups of forty or forty five pupils per session. **Antón Martín** painted a watercolor a long time ago which I have always admired. In fact I like it so much that it has appeared in two or three of my books, specifically on page 63 of *Techniques & Color* of this collection. This painting is now hanging in the permanent collection in the Catalonian Watercolorists Association. So **Antón Martín** will paint this for us and **Paco Vila Massip** will record the step by step process in photographs.

Paco has prepared **Antón Martín**'s original picture (fig. 151), by hanging it from a pressure supported floor to ceiling bar in the studio. **Antón Martín** places the drawing board and paper on an easel in front of the original and begins to draw with a 2B pencil. He then says: "Whenever you are ready!".

Let me first say that **Antón Martín** is a different and original watercolorist. He is quick and has an exceptional grasp of watercolor technique but without tricks or special means. Because as he himself wrote: *"I do not like liquid eraser or any other especial technique. Nothing that I cannot do with a brush, water and rag"*. He does not mount the paper but simply attaches it with drawing pins in each corner. He absorbs water or color with a rag. He paints with creamy colors from a box-pallet and paints the entire watercolor with one brush, a thick, ox hair, number 22 brush! When he is painting he is really a true phenomenon. He painted this copy in little more than half an hour. He produced a new work almost from memory with just the occasional glance at the model.

He made the drawing with a 2B pencil and worked the entire time with the pencil in his hand working in a somewhat anarchic way. He draws a number of outlines and finally plumps for the one or ones he wants. It is as if the drawing was not

152

153

important to him (fig. 152). And the color? It is difficult, if not impossible, to explain how he works. He begins with some forms on the left hand side in a Prussian blue wash. At first these forms seem abstract (fig. 153) and then he draws and defines on the wet surface, re-absorbing colour and resolving the jug on the left with the cleaned brush.

He constantly adds water whilst reabsorbing and drawing at the same time (figs. 154, 155 and 156). I asked why he uses this number 22 brush and not the flat brush which would seem to be more comfortable and functional. He explained and showed me (fig. 157), that by squashing the end of the brush when absorbing water or

154

155

color, the hairs open up like a fan and work rather like a knife but with the advantage that with only a small movement of the fingers it changes back into a brush. A brush that **Martín** uses as if it were a game, drawing and painting circular and concentric forms, straight lines and curves and at the same time reserving white areas and controlling the degree of wetness knowing that any addition of color will not invade the white reserves. The brush works like a little sponge that lightens and sucks up the water like an extension of his arm, of his hand and of his thoughts.

Martín has a way of painting that is the fruit of years of teaching experience and an extraordinary way of manipulating the brush. He does not paint wet on wet because he does not initially wet the paper. He paints washes and mixtures on top of the washes added to his way of absorbing and lightening make it look as if he is working completely with wet on wet.

As I said in one of the previous paragraphs, it is difficult to explain how **Antón Martín** paints, so by remembering that ancient Chinese proverb which assures us that *"an image is worth a thousand words"*, let me explain the step by step development of this painting with images and related texts starting with figure 151. Look at and read the images and texts on these pages and follow the process until you see how **Martín** finishes this splendid watercolor.

156

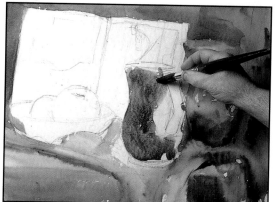

157

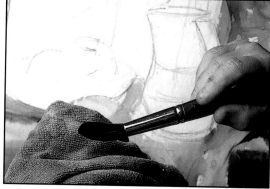

158

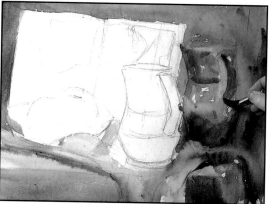

159

Figs. 151 and 152 (on the opposite page). The subject on this occasion is a painting done some time ago by Antón Martín which he himself is going to copy step-by-step (fig. 151). The drawing and the peculiar way in which he holds the pencil (fig. 152).

Figs. 153, 154 and 155. There is no rule or method here. Martín begins to paint in an anarchic way on the right hand side. It seems abstract but soon the form of the jug and its lights and shades "appears".

Figs. 156 and 157. More of the same with a number 22 ox-hair brush! Brush and pallet knife with which our guest paints.

Figs. 158 and 159. With deliberate strokes, painting wet on wet, making use of the small white areas and highlights reserved from the first paint strokes of the blue jug, the artist begins to paint the gray jug with a dark wash.

Painting a Still Life in a Cold Color Range

Figs. 160, 161 y 162. He has absorbed and reduced the color of the gray jar, painted some gray and pink washes on the open book (colors which he obtains from the remains left on the pallet), and paints the fruit bowl or plate in Prussian blue which he intensifies almost to a black with burnt umber and Payne's gray (fig. 160). And he begins to paint the two apples, the red one in carmine, cadmium red and ochre and the yellow one in dark cadmium red and cadmium red with some touches of Prussian blue in the dark areas. Notice the agility with which he resolves the border and the shine of the fruit bowl with nothing more than the number 22 brush and with a control and synthesis which he always achieves.

Fig. 163. The fruit bowl and the highlighted fruit are ready. Now he starts on the gray jar which he paints with Prussian blue and Payne's gray, more gray than blue. Notice how he paints the shadow of the jar across the blue cloth which he paints with a dark blue stain but reserves a white outline along the left hand side of the jug.

Figs. 164 and 165. He continues by painting a dark black stain in the upper right part of the book which he extends to the neck of the gray jar. He outlines the shadow of the handle of the gray jar with a steady hand. He continues to use the thick number 22 brush, which apart from being of ox hair does not usually offer a very fine point.

160

161

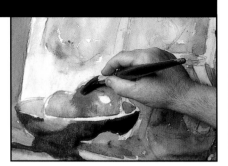

162

163

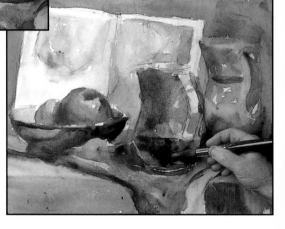

164

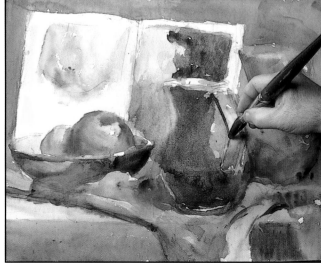

165

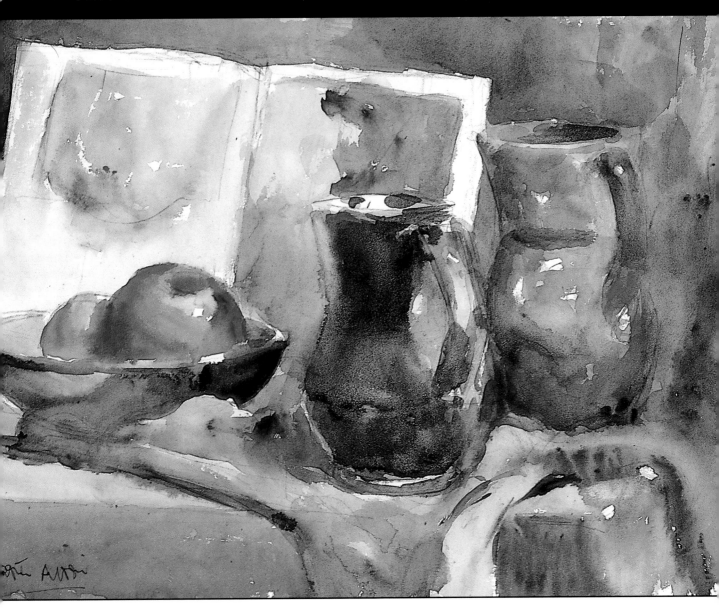

Fig. 166. This is a different kind of watercolor in which, as they say and as you can see, one touches the water. A work in which the technique of painting wet on wet is predominant. A work which gives us a really artistic harmonization of color with a dominant blue, that wonderful Prussian blue with the harmonic dischord of regal carmine of the red apple. A touch of warm color on a cold background. It is The Contrast of Colors as stated by the pedagogue Johannes Itten, professor at the German Bauhaus where, in 1919 he was a contemporary of Paul Klee and Vasili Kandinsky. This is a watercolor to remember and imitate, to imitate its technical development, its synthetic capacity and harmonization of colors.

Painting a Still Life in a Warm Color Range

167

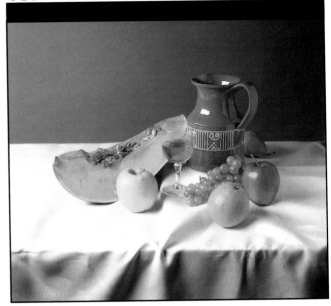

I went to the market to buy fruit for this still life. As a basic element I had thought of a melon but it was not the right time of year but I found a fantastic, cadmium orange pumpkin. I asked the woman, "Will you sell me a slice?", and of course she let me have it. I bought apples, pears oranges and a bunch of grapes. Later in **Paco** the photographer's studio I added an earthenware pot, a glass of rosé wine and a cream coloured table cloth forming a group of yellow, ochre, orange, English red, vermilion, carmine and, as an exception, the green of the pear. That is undoubtedly a warm color range (fig 167).

As usual I drew the subject with a 2B pencil. I started with the centralized vertical and horizontal lines forming the cross that I always draw to help with the calculations of dimensions and proportions (see the drawing in figure 168).

The background is painted with a mixture of Payne's gray and a small quantity of ochre, the cloth with ochre and cadmium lemon yellow, the pumpkin with dark cadmium yellow and red and the jug with English red and a bit of ultramarine green for the shadows.

Up to here I have used a flat sable brush of 2 cm and two round 10 and 12 brushes. I have been very careful to conserve the whites for the pumpkin pips and the shine on the jug without further elaboration (figs. 169, 170 and 171).

168

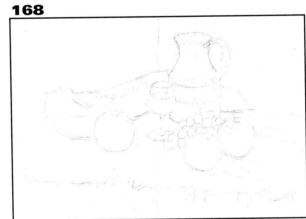

Figs. 167, 168, 169 and 170. The model and the drawing. The background and the beginning of the painting starting with the table cloth in ochre and yellow and the color of the slice of pumpkin with dark yellow and red.

169

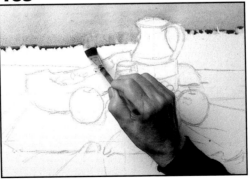

170

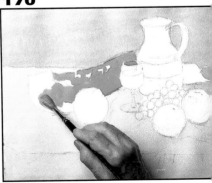

171

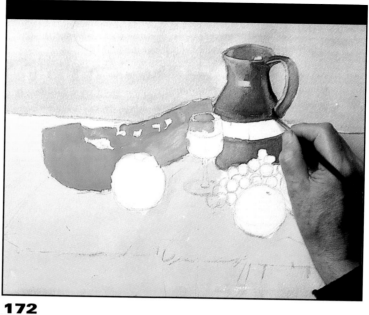

In the following figures 172 and 173 there appear to be few changes. The pear in the shade is painted with permanent green mixed with English red to darken the brightness of the green. The yellow apple is painted with cadmium lemon yellow and ochre mixed with cobalt blue for the shadow and the orange with dark cadmium orange and cadmium red. As you can see, I intensified the color of the cloth. All this in figure 172.

In figure 173 I painted the wine in the glass and the red apple basically with carmine and yellow being careful to conserve the whites. But don't you see a difference in the form and color of the jar at this stage compared to the last? Yes. I did not like the coloring nor the form of this jar so I rubbed it out by wetting it and with the use of absorbent paper until I was able to rectify the forms and colors of the mouth and the reflections on the right hand side and the yellow patterned decorative border. The more intense highlights of the jar were for later.

172

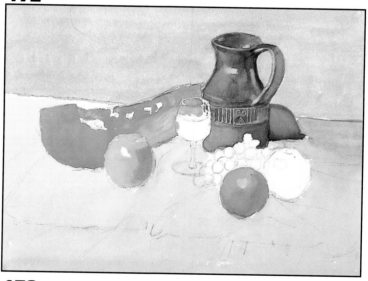

Figs. 171, 172 and 173. I began to paint the jar (fig. 171) and I finished it and I also painted the first coat on the apple, orange and pear (fig. 172). But I do not like the jar, I am not satisfied with the color or the form. The perspective of the decorative border was not correct, nor was the circular mouth and I think the form of the reflections on the left hand side were false. So I rubbed out the jar with a synthetic brush, water and absorbent paper and painted it again, as you can see in figure 173. It is better, don't you think? All that remains is to intensify the reflections on the neck and body which I will do later. Oh, I forgot! I also reinforced the color of the orange, I painted the red apple and I coloured the wine in the glass but maintaining the whites of the glass.

173

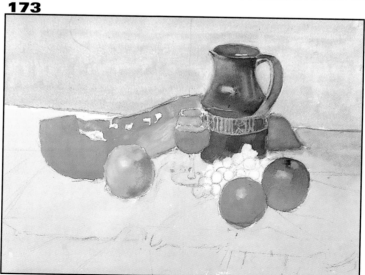

Painting a Still Life in a Warm Color Range

I continue by darkening the background with Payne's gray and ochre and then a first coat on the bunch of grapes. I then resolve the intense colors of the pumpkin in the area of the pips and I intensify the shaded area next to the pear (fig. 174).

I paint the glass, the wine, the grapes and the pumpkin shadow between the cup and the yellow shadow (figs. 175 and 176).

I begin to sort out the folds of the cloth but before that I intensify the colour of the surrounding shadow (fig. 177). I think several things need to be corrected. The background color should be darker and the color of the cloth, more intense.

174

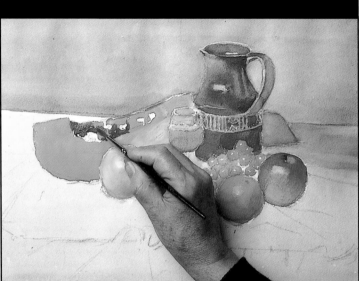

175

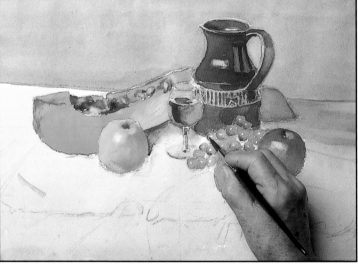

Fig. 174. In this figure the only variations are the start of the top of the slice of pumpkin and a first coat on the bunch of grapes.

Figs 175 and 176. Here there are more things. In the first place the color of the jug is intensified to the maximum. Note also the finished glass of wine, and finally, the yellow apple is almost finished.

Fig 177. The biggest change here can be seen in the pear behind the jug. The color is more intense and so is the shadow it creates. I also started the painting of the folds of the table cloth.

176

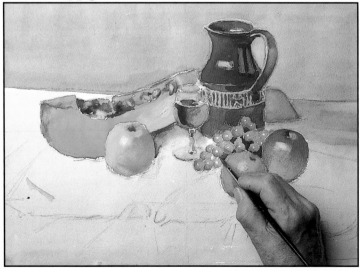

177

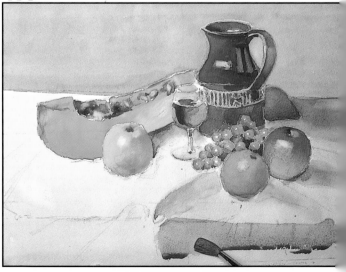

178

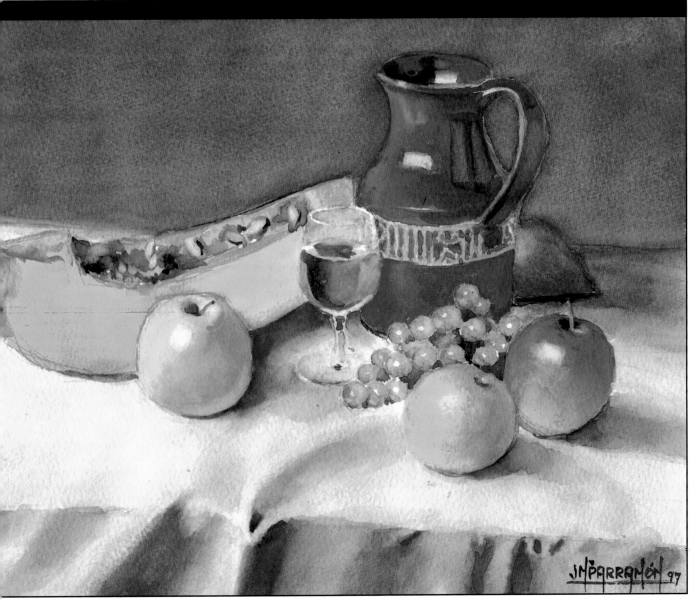

I also have to correct the squaring up as I have been painting with excessive spaces above the jug but above all, on both sides.

These and other finishing touches are reflected in the finished watercolor in figure 178 on this page. Apart from the darker background and table cloth, I have drawn and painted the folds of the cloth. I have created the white areas of the pips on the slice of pumpkin and drawn and painted the area surrounding the pips in burnt umber and carmine. I have touched up the grapes and the earthenware jug where I have cleaned up and accentuated the reflections on the mouth of the jug and added some soft reflections in the upper left hand area. I have drawn in the stalks on the apples and perfected the forms, shines and reflections of the wine and the glass. I have also painted the handle of the jug and added a highlight to the pear. That is all. So here you have a watercolor of a still life in a warm color range.

Fig. 178. This is the finished work with last minute changes and touches with the important ones being the alterations to the composition with the reduction of the spaces of the upper area and the sides as I thought these were too big and detracted from the overall balance of the composition. But there is more. I intensified the background color and gave it a warmer tone. I also intensified the color of the table cloth and added some light reflections on the mouth of the jug. I will leave it here. All the other details are carefully explained in the main text.

Painting Animals in Watercolors

When you see artists such as **Jordi Segú**, **Gaspar Romero** or **Vicenç Ballestar** painting animals with the same ease as they paint fruit, trees or figures, you appreciate that they are extremely talented artists. It is clear, of course, that fruit, trees and figures stay still while you are painting them. But animals? There are some such as flamingos, giraffes or elephants which do not move much and dogs, cats, chickens or cockerels are still when they are sleeping. But try telling a dog, cat or chicken to stay still when it is not asleep! Despite this "They" draw them. How? What do they do? How do they do it? The short answer is that they know how to draw. They are draughtsmen who are used to making quick sketches of the figure, to calculating dimensions and proportions in a short time, in a very short time. It also helps if you are a specialist in drawing and painting animals like **Vicenç Ballestar**.

The second basic answer is that by drawing animals over and over again as **Vicenç Ballestar** does, they are capable of drawing from memory even if the subject is moving but using it as a reference point. Any artist who has become a good at drawing the figure through constant practice is capable of drawing a figure from memory. If you draw a lot of animals and you have spent time drawing the heads, bodies and legs of animals you will be able to recall and memorise the forms. This is also true when you have the subject in front of you, even if it is moving.

But let's have a practical look at all this on the following page.

The artist **Jordi Segú**, the photographer **Paco** and myself went to Ciutadela park in Barcelona. We went to the zoo to photograph and draw and paint some animals in watercolor. It is a gratifying experience, good fun and also very didactic. I highly recommend it. If there isn't a zoo near you I suggest you visit a farm where you will find cows, pigs, cockerels, chickens and ducks.

At the zoo you will have to ask for written permission which is easily given. So let's continue with our visit to the zoo.

179

180

Figs. 179, 180 y 181. A flamingo and a giraffe painted by Gaspar Romero and a cockerel painted by Vicenç Ballestar, two good examples of sketches made at the zoo and on a farm, showing the lightness and spontaniety of the two expert artists.

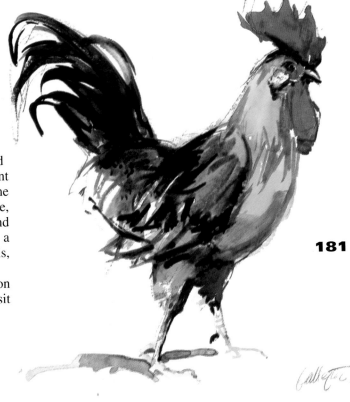

181

As soon as we enter the zoo, on the left, we see an enclosure full of tree trunks, a small lake and rocks and two Canadian brown bears. They are restless animals that constantly walk up and down and in circles around their cage (fig. 182). **Segú** prepares his paper and file, the box of watercolors and a pot of water placed on a low wall and he begins to study the subject in order to remember the forms and movements. He looks and looks again for more than ten minutes. Some young boys visiting the zoo became interested in what an artist, a photographer and a man talking into a microphone were doing standing there, but they finally lost patience and moved on. "He's not doing anything. He's not painting a thing". Segú continues to stare and study the bears and when he finally starts to paint he does so practically from memory. He draws the head, the body and finally the legs. With the bear finished he moves on to the background with a light green and then a wash of light English red which changes to a bluish tone near the head. He continues with English red mixed with a little ultramarine blue. He paints the feet and a dark touch of this dark color on the eye and ear (fig 183). He moves on to the second stage in which he adds more brush strokes and practically finishes the head and some light strokes to highlight the animal's coat (fig. 184). In the third stage he finishes the painting of the bear with some light touches in a vertical direction to explain the form of the animal.

182

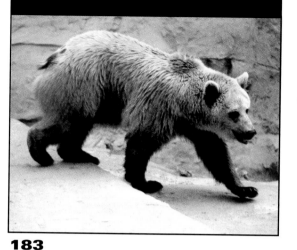

183

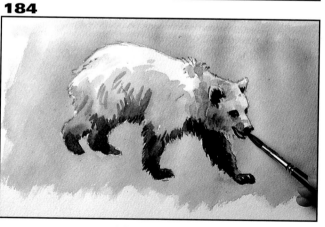

184

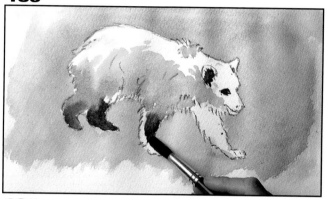

185

Figs 182 to 185. Jordi Segú painted various animals at the Barcelona zoo. The first was this Canadian brown bear which was very restless and so the artist had to study it for a long time to memorise its forms and movements.

Painting Animals in Watercolors

186

A bit further on we saw some dromedaries, or camels, and I suggested to **Segú** that he paint the head of one of them that was sitting down quietly (fig. 186).

Segú was able, as the animal did not move, to begin the drawing quite quickly, with only a short observation period. Segú finished the drawing of the head seen in profile in only a few minutes, drawing with a sure, continuous line. He painted the background with Payne's gray and a little ultramarine and in the shady part of the head and neck he

187

Figs. 186 to 189. The camel stayed still while Jordi Segú painted, without pausing but neither hurrying. He drew and painted it in some fifteen minutes with the advantage that the animal remained in one position throughout.

used a mixture of English red, gray and the blue used for the background (fig. 187).

He painted the upper part of the body with accents of English red but retaining the white areas, the upper light parts of the profile and he began to model the head with touches of English red, Payne's gray and ultramarine blue (fig. 188).

In the last stage he draws and paints the hair and coat of the animal's upper and lower neck areas. He models the forms of the head, the ear the eye the nose and mouth with light touches of more or less intense colors and finally leaves this fine sketch saying, "That's enough. I like it as it is, don't you?" "So do I", I say, and he leaves it.

188

189

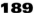

And then we found the giraffes which **Paco** photographed (fig. 190). Here the person painting and drawing is myself, **Parramón**. By the way, in this case the problem of movement practically does not exist as giraffes, in general, maintain positions for a relatively long time. If you go to the zoo I recommend that you begin with giraffes as a first model for this very reason.

190

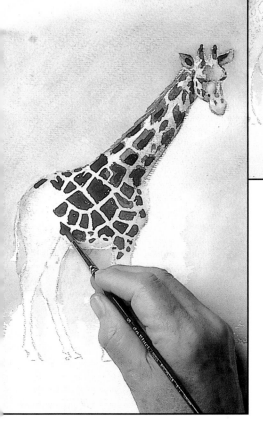

I draw the giraffe and the minuscule details of the typical markings of this animal with a 2B pencil. I cannot stress too strongly that you have to pay attention to what the model "says". I take advantage of the moment that the giraffe turns its head which I draw at a three quarters angle rather than the profile. I then paint the background without too much attention to the real details and colors which are somewhat complex (fig. 190). I put in a light green background, which is lighter on the right hand side under the neck. I resolve the mane and the cylindrical form of the neck and I paint the features of the face (fig. 191).

I continue with the patient work of drawing and painting the marks that cover this animal with flat colors, almost without light or shade. I paint the marks with burnt umber (fig. 192). I then move on into the finishing stages having finished the markings. I start to absorb color in order to create dark patches and shades on the neck, back and flanks. I paint the tail and with a little Payne's gray, English red and a speck of Prussian blue, sorting out the pale spots on the right hand side of the body, the belly and legs and decide the sketch is finished (fig. 193).

191

192

193

Figs. 190 to 193. Here it is I who is painting, without many problems as the giraffe stayed still. You have to be careful with the typical markings on the neck and body. They are forms that have to be drawn extremely accurately.

Painting Animals in Watercolors

194

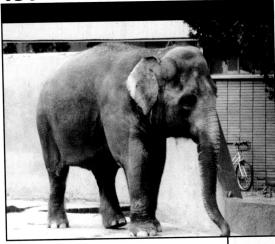

And so we continue. We walk further into the park where we find the elephants in a relatively open space. In fact, to the delight of the children some of these animals come right up to the fence that separates them from the public. One elephant remains still next to a red brick wall (fig. 194). The stillness of this animal allows **Segú** to draw it in a short time. He captures a moment in which it curls its trunk back. He paints this first stage in a general wash of Payne's gray in which the basic form of the animal can already be seen. For the

Figs. 194 to 197. Again Jordi Segú captures the image of an elephant which he draws and paints with the perfection of a definitive watercolor. Really you just have to admire the forms and the magnificent color of the animal in figure 197.

background he paints an almost imperceptible cream (fig. 195). He continues modelling with the same color tone but now he adds some touches of English red which create these pink colors you can see on the model. Observe the ease with which **Segú** paints. He adds patches of color which later become blended and worked into the general form of the animal (fig. 196). He begins the last stage with the same color tone but also with a diverse selection of tones and hues which enrich the drawing and painting within what is an unmistakable watercolor finish (fig. 197). Notice the finish of the head with the perfectly drawn and painted eye and the rest of the body and trunk done in a series of patches and marks which synthetically reproduce the forms,

195

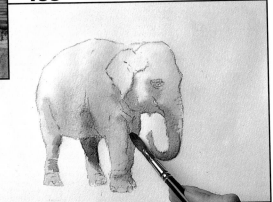

196

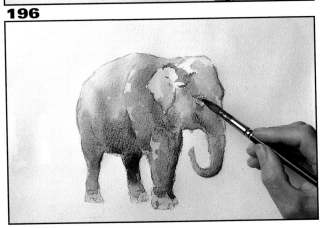

197

tones and colors of the model. This is an excellent work, an excellent way of finishing this series of watercolur sketches of animals.

Painting the Human Head

The woman's head that appears on the cover of this book and which you can see in the adjoining figure 168 was painted some time ago by my friend **Gaspar Romero** at one of the painting sessions at the Barcelona Artistic Circle. So Gaspar is going to paint this same head by copying the original watercolor.

Now that we have come to the subject of painting the human head let me remind you of the illustrations (fig. 200), of the canon of the human head and face. It is a practical formula which should be applied to the drawing of heads and faces in general.

Gaspar Romero draws the head with a 2B pencil (fig. 199) by holding the pencil with the end in the palm of his hand as you can see in the photo. This way of holding the pencil allows for a freer, more spontaneous way of drawing.

Now **Gaspar** begins to paint. He starts with the background with the painting in a vertical position. He dampens the entire background area with a 4.5 cm flat brush. Then he makes a mixture of English red and ultramarine blue with abundant water with which he paints a light wash (fig. 201 on the next page), across the paper to the center, just below the head and with the same brush and the

198

199

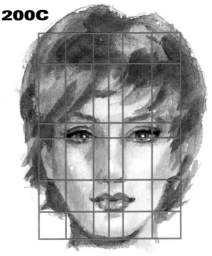

Fig 198. The model which in this case is the head that appears on the cover of this book. An image by Gaspar Romero which he is going to copy for us to follow the step by step development.

Fig. 199. The drawing carried out by the accomplished artist Gaspar Romero.

200

CANON OF THE HUMAN HEAD

Fig. 200. The canon of the human head is composed of various measurements or modules. The height of the head as seen from the front measures three and a half modules and the width, two and a half modules (fig. 200A). The profile (fig. 200B) is equal to three and a half modules. Observe the coincidence of the facial features with the following modules.

A) The top of the head without hair.
B) The point of hair growth.
C) The position of the eye-brows.
D) The position of the eyes.
E) The end of the nose.
F) The profile of the lower lip.
G) The bottom or profile of the chin.
Notice that these positions coincide with the head seen in profile (fig 200B). Take note of

the following information.
 The eyes are situated in the center.
 The distance between the eyes is the same as the length of one eye.
 The height and position of the ears coincides with the eye-brows and the end of the nose.
The canon of the woman's head is the same as that of the man's (fig. 200C).

200A **200B** **200C**

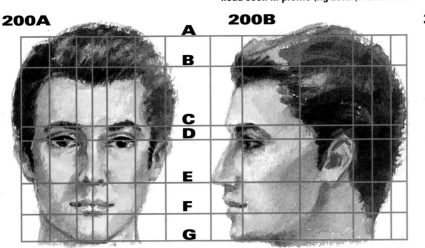

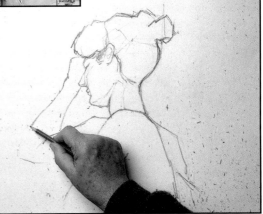

Painting the Human Head

same mixture but a little darker he paints this more intense area (fig. 202). He remembers **Leonardo da Vinci**'s precept which states,

> **"The background which surrounds a figure should be dark in the illuminated part of the figure and light in the shaded part".**

He finishes the background and begins painting the figure's hair. This is a decision made to avoid the effects of simultaneous contrasts, which as you will remember establish the fact that a color is more or less light depending on the color that surrounds it. In this case the flesh tones of the head and neck can be altered without having resolved the dark color of the hair.

He paints the hair with a coat of a mixture of Payne's gray and sepia. Now he waits for this wash to dry in order to paint the intense blacks which define the form of the hair (fig. 203). While he is waiting he paints the area of the red cloth which the model is wearing on her arm and back (fig. 204).

He begins to paint the flesh color with a light wash of sienna and cobalt blue and abundant water. They are the lightest colors which correspond to the light. He paints the shadows on the arm with a mixture of cobalt blue and burnt umber and blurs the light into shade. He continues with the same mixture and paints the shadows on the face and neck (fig. 205). He always paints from light to dark by painting a new darker film which definitively adjusts the color and models the figure (fig. 206).

He draws the eye in Payne's gray (fig. 207) although, as he says, he will reinforce and finish with an Indian ink stick.

201 202

203 204

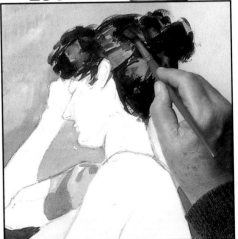

205

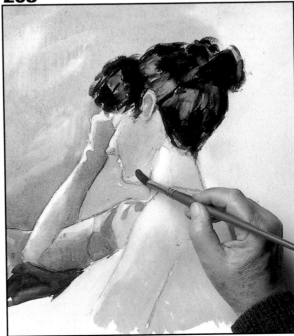

Figs. 201 and 202. Here Gaspar paints the background on the vertical board, first with a light wash (fig. 201) which he later intensifies.

Figs. 203 and 204. Here he paints the hair with a big, 2 cm brush for the first touches and then he finishes with a number 12 sable brush.

Fig. 205. And here he paints the flesh tones with a general wash of the same tone. He reserves the whites, the light on the arm, face and neck.

The technique that characterizes **Gaspar Romero** which he normally applies to the painting of nude studies when he is painting at the Barcelona Artistic Circle (fig. 208), consists of going over the outlines and contours of the figure with a wet Indian ink stick which allows one to draw while the stick is damp but at certain moments it dries up with the result that the lines are irregular. This irregularity of marks

206

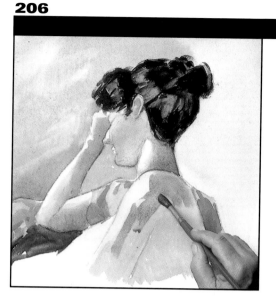

207

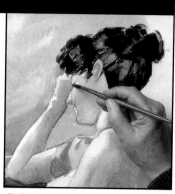

208

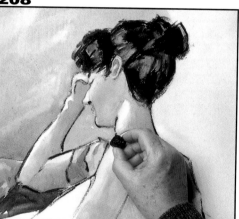

gives a spontaneous effect, a dragged effect which benefits the finish of the drawing and painting (fig. 209). Very good, **Gaspar Romero**. It is a magnificent copy and an excellent watercolour. Congratulations, **Gaspar**!

Fig. 206. He now intensifies the shaded skin color with a number 12 brush.

Figs. 207 and 208. He draws and paints the eye and then (fig. 208) he reinforces it with the technique of going over it with a damp Indian ink stick.

Fig. 209. The head is finished. It is a perfect copy produced with great spontaneity. He paints with relaxed strokes as he already knows this lesson. Pay attention to the finish of the hair, left like this from the first stages in illustrations 203 and 204 on the opposite page. Observe the sureness of the first step (203) in which he consolidates the hair style with its lights and shades *au premier coup*. The finished area (204) will appear as it is in the finished work without any changes. Absolutely, Gaspar! That is how you paint a watercolor!

209

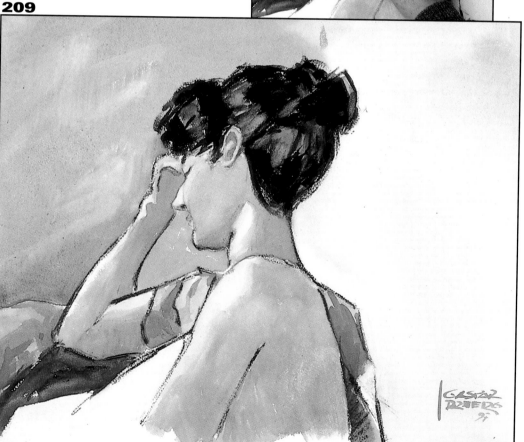

Painting a Portrait of Julia

210

Mercedes Gaspar, **Merche** to us, the qualified fine art professor, is going to paint a portrait of her niece, Julia. **Gaspar Romero** who is **Merche**'s father and **Julia**'s grandfather is here with us today. But let us look at **Julia** the model in figure 210.

Before starting to paint **Merche** puts **Julia** into a pose. She then takes a sheet of 300 gram, Fabriano paper which she immediately pins to the drawing board, checks the pose again and is ready to start.

Merche outlines the eyes and begins to draw with her 2B pencil. Observe in figures 211 and 212, the two ways in which **Merche** holds the pencil. With the end in the palm of her hand in both cases but almost at the point when she has to draw with more precision, around the eyes for example (fig. 211), and then further up the pencil, holding and pushing with the index finger when the lines are not so precise (fig. 212).

Merche says the drawing is finished but then begins to hesitate. "One moment!", she says. She then reaches into her bag and produces a small mirror.

She looks at the drawing in the mirror and comments,

"Using a mirror is a give-away, it reflects the errors in the drawing".

Actually, she is following **Leonardo da Vinci**'s advice. He wrote,

> **"When you want to know if all your painting conforms with the natural object, take a mirror and reflect the model in it then compare what is reflected with your work and see if the original agrees with the copy".**

Merche checks that "the painting is in agreement with the natural object" with the mirror and then gets ready to paint. But she continues to study the model for quite a long time. She examines the colors, contrasts and lighting.

Fig. 210. Julia the model and niece of our guest artist, Mercedes Romero, and granddaughter of Gaspar Romero, my friend and collaborator.

Figs. 211, 212 and 213. In these two drawings of Julia you can see the two different ways in which Merche holds the pencil. In figure 213 see how she holds a flat brush to paint a general wash.

212

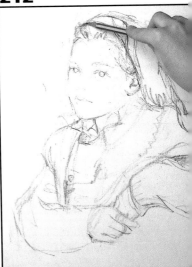

211

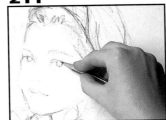

213

214

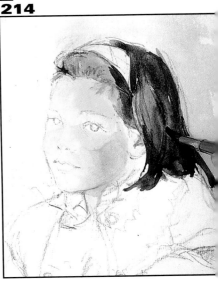

Following this she takes a flat, 4 cm brush and begins to paint the background with a violet, cobalt blue and carmine wash. She uses the same brush to put on the first coat of the face, starting at the top and working downwards with a mixture of ochre and cadmium red (fig. 213 on the opposite page).

She immediately starts on the hair with a number 12 sable brush loaded with burnt umber which she mixes with Payne's gray and the violet left over from the background. With tentative, slow movements she treats the hair area by sliding the brush in broad sweeps from top to bottom (fig. 214). She continues with the hair by adding some light touches and creating white spots for the highlights by absorbing paint with the same brush. She concludes by reinforcing the yellow hairband and puts a first wash on the hands, dress and the chair.

She then gives **Julia** a short break in which she comes over to admire the work so far and congratulate her aunt before our guest goes back to work on the portrait.

With a slightly more intense color made up of burnt umber and a little Prussian blue she paints in the basic side tones, on the forehead, the nose and the right hand cheek which accentuates the light falling on **Julia**'s face (fig. 215).

Silence returns. Within the room you can only hear the tap, tapping of the brush in the water pot. **Merche** is washing the brush and then with a little carmine and red she puts the first touches on the lips and mouth. Then with the same brush she paints the eyes with some intense burnt umber with which she also paints the eyebrows, retouching and outlining with the very tip of the brush. She returns to the hair giving it more colour and strengthening it. Then back to the mouth which she intensifies. She retouches the tones of the skin surrounding the eyes and makes the colour of the cheeks rosier (figs. 216, 217 and 218).

215

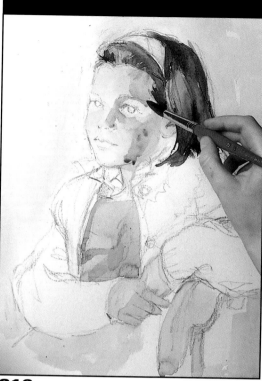

Figs. 214 and 215. With a number 12 paintbrush Merche paints the hair of the model, her niece.

Figs 216, 217 and 218. Now with the same number 12 brush Merche paints small details like the eyes, eye-brows and mouth.

216

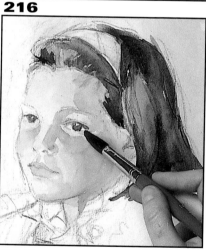

217

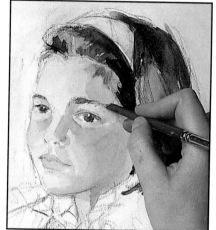

218

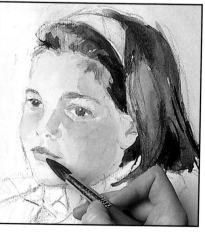

Painting a Portrait of Julia

219

220

Merche's eyes are constantly moving back and forth between the watercolor and the model, contrasting the result of her work with the reality of the model. As you can see in figure 221, the artist adopts a comfortable position in front of the model which allows her to paint the model with only the slightest movement of the head or just by lifting her gaze.

Julia begins to get tired again so Merche, her aunt, tells her to drop the pose and relax. Julia comes over to see how her portrait is shaping up.

Julia and Merche get back to work. With the same number 12 brush Merche begins to paint Julia's clothes by applying a wash of raw umber, carmine and a little ochre (fig. 219). She now adds a bit of burnt umber to the mixture and paints the folds and creases of Julia's clothes (fig. 220). Finally Merche paints Julia's shirt collar with dark burnt umber and a speck of cobalt blue and the back of the chair with burnt umber and Payne's gray. Then she signs.

Merche is satisfied. Julia and her grandfather are at her side.

"What do you think, dad? And what do you say, Julia?"

"Very good, Merche, it's very good", her father affirms.

"Wow, it's great!", exclaims Julia, and after hugging her aunt she asks: "Will I be able to paint like you one day?"

"Yes, as long as you study, draw and practice a lot".

The answer is the same for children as it is for adults.

Figs. 219 and 220. Merche paints the clothes, the hands and the chair. The face and hair are already completed.

Fig. 221. Our guest artist, the qualified artist and teacher of drawing and painting, Merche Romero painting the model, Julia.

221

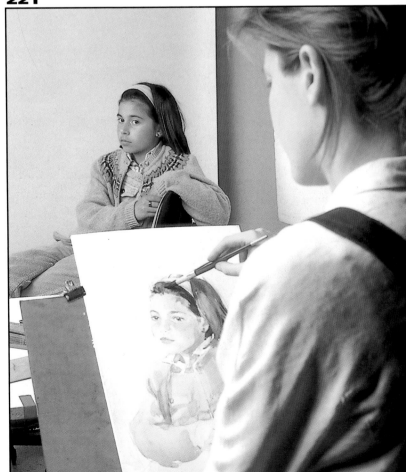

222

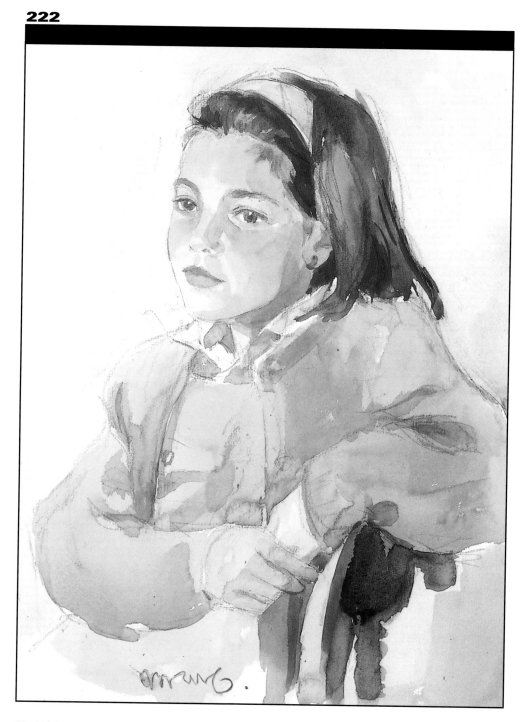

Fig. 222. The finished portrait of Julia. Merche Romero has achieved two fundamental aspects of a good portrait. The first one is the artistic quality which is reflected in the accomplished drawing and in the technical expertise and color control. In this watercolor I would call the color "sweet color" as is necessary for a portrait of a young girl. The second aspect is the semblance to the model which is something that you cannot always count on. Who worries about similarity in the painting of Pope Inocencio X by Velázquez? But for us, the model Julia, Merche the artist and Julia's aunt, Gaspar Romero and his wife Pilar (Julia's grandfather and grandmother) it is important and it does count.

Painting a Figure in Watercolors

223

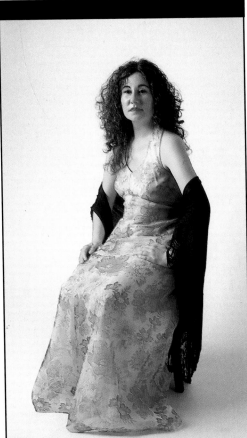

Jordi Segú is going to paint a clothed figure. The model, who came well prepared, showed us a number of outfits. She showed us a yellow jacket and mini-skirt, a pink blouse and gray trousers, a long, white, floral silk dress and a black shawl. We decided on this last combination. The model sits on a high stool facing forwards but with her body just off center and her face looking at the artist, following what **Ingres** said to his students. He said,

> **"Concentrate on the pose**
> **of the head and body.**
> **The body should not follow**
> **the movement of the body".**

Paco the photographer positions a frontal side lighting arrangement and **Amelia**, the model, starts her pose (fig. 223). **Jordi Segú** starts to draw. He does so with soft strokes of a number 2 pencil which he later strengthens with a 2B. He uses Fontenay de Canson, 37 x 50 cm paper. **Segú** begins by carefully squaring up the models face and draws the hair, eyes, nose and mouth. Then, still with the 2B pencil he completes the rest of the figure (fig. 224).

Segú begins the painting with a background of Prussian blue, English red and at determinate moments, Payne's gray (fig. 225).

Then, right away, he starts painting the face. Strangely enough the first thing he begins on are the eye-brows and eyes with Prussian blue and Payne's gray followed by the upper and lower lips with carmine and a bit of English red. Do not forget that he does all this on the still white paper (fig. 226).

He now moves on to the hair and the color of the face, neck, bust and arms. He paints the hair with a wash of Prussian blue, English red and Payne's gray and models the effects of light and shade in a light or medium tone which he will later strengthen.

Fig. 223. After trying on various outfits, Amelia the model poses in a long, flowery silk dress and a black shawl. She sits on a stool with her head forwards and her body off center.

Figs. 224 and 225. The drawing in 2B pencil and the background done with a number 12 brush.

224

225

226

He will intensify and model the color until he gets the black of the model's hair. He paints the face, neck, bust and arms at the same time, beginning with the darkest areas with a mixture of cobalt blue, carmine, English red and ochre which he dilutes and grades to make the lighter areas. But both the hair and the skin color are painted in a medium tone (fig. 227).

He paints the hand with a skin colored wash and the dress, first with a general wash of vermilion, carmine and abundant water. For the shadows he applies ultramarine blue mixed with carmine and vermilion (fig. 228).

227

228

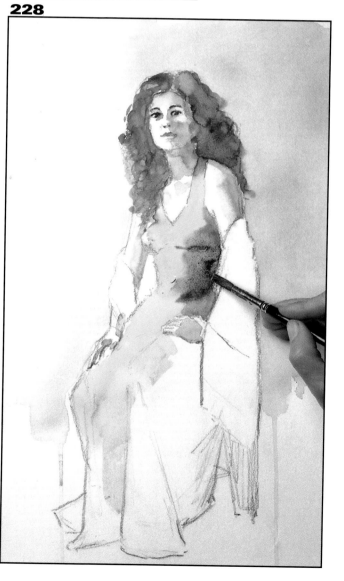

Fig. 226. With a thin number 6 paintbrush Segú begins to paint the figure and as an exceptional case he paints the features of the face, the eye-brows, eyes, nose and mouth first, without having painted anything else.

Fig. 227. Segú now paints the first touches of skin color on the face and a first wash for the hair. You can see both on the face and hair, the first indications of light and shade.

Fig. 228. He follows on with the dress in a general pink wash and the first touches for the shadows on the chest area.

Painting a Figure in Watercolors

He extends the color of the shadows across the dress and begins on the shawl with a mixture of Payne's gray and Prussian blue which forms an intense black (fig. 229). In figure 230 we can see the shawl as it appears in the finished painting.

Segú paints directly without any previous rehearsals. He has, next to his paint box, a number of folded up bits of absorbent paper which he uses every now and then like a sponge, to absorb water and color from the brush.

Now he perfects the eyes with a mixture of Payne's gray and ultramarine blue. He starts strengthening the color of the hair with ultramarine blue (fig. 231). He works on the face and concentrates on intensifying the color of the cheekbones and the chin. He harmonises the colors of the face and finishes the modelling of the hair and so concludes the work on the face, hair and bust in general. He paints the flower patterned dress with a mixture of magenta, red ochre and in some places, ultramarine blue. He is still strengthening the dark areas of the shawl and he intensifies the color of the hands (fig. 232).

Figure 232 shows the finished watercolor. It has a loose, spontaneous feel, executed by an accomplished expert in watercolor painting.

229

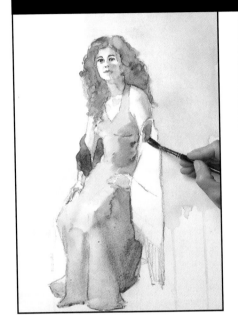

230

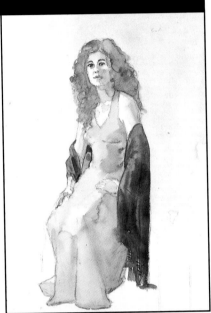

231

232

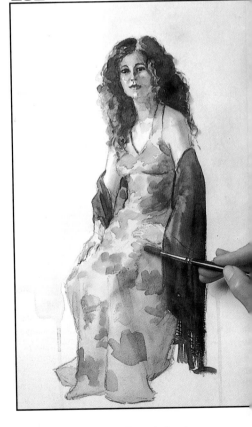

Figs. 229 and 230. He continues work on the dark parts of the dress and finishes the black shawl with a finish that he does not touch again and appears like this in the final work.

Figs 231 and 232. He begins painting the hair (fig. 231) which he finishes in the next illustration. He also finishes the dress and its pattern of roses.

233

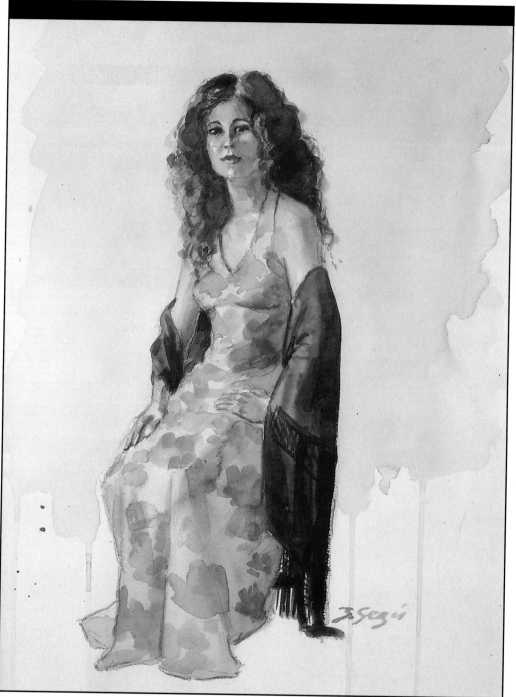

Fig. 233. As I write these lines I have before me Jordi Segú's watercolor. It measures 37 x 50 cm, which as I have already said, is a great deal bigger than this reproduction. I say this because despite the fact that this reproduction is good it not as good as the original. In the original watercolor one can see and appreciate the details of the finish better. The treatment of the hair for example, with its curls, grays and blacks is an example of how to explain form and color through synthesis. Or this blue tone, perfectly graded which models the upper part of the arm. Or this other pink hue in the part of the shawl covering the arm, an almost imperceptible shade mixed into the black which illustrates and describes the transparency of that part of the shawl with the arm barely visible through it. So really you would have to see the original to appreciate the watercolor better and the quality of the work of my good friend Jordi Segú.

Painting Nudes in Watercolors

234

Gaspar Romero is going to paint a nude study of a young model. The first step is to determine the pose. In **Paco** the photographer's studio there is a big sofa covered in a patterned cloth. **Gaspar Romero** suggests that the model lies down on it. **Pepa**, a professional model, tries out various poses until **Gaspar** decides on the last (fig. 234).

Gaspar Romero begins to draw with a typical number 2 pencil and a few touches of a soft rubber and once he has structured the drawing with this pencil he continues with a 2B.

The proportions and dimensions of the human figure are relatively simple when standing up given that the artist is able to make calculations based on the canon of the human figure which was established in the Renaissance period, a canon made up of eight heads of height. See the adjoining figures 235 and 236. Here we have the canon of the female and male figures. Notice that the latter is slightly taller.

Fig 234. The model in the pose chosen by Gaspar Romero.

Figs 235 and 236. The canon of the human figure, composed of the height divided into eight parts, each part equivalent to one head,

and two heads wide. See the notes written in the adjoining illustrations and always bear in mind that the female figure is slightly shorter than the male.

236

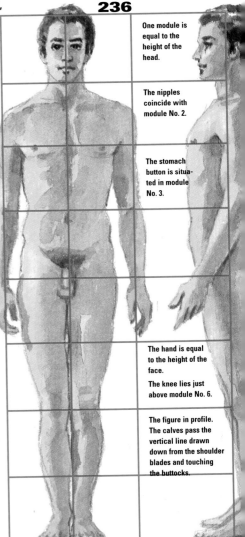

One module is equal to the height of the head.

The nipples coincide with module No. 2.

The stomach button is situated in module No. 3.

The hand is equal to the height of the face.

The knee lies just above module No. 6.

The figure in profile. The calves pass the vertical line drawn down from the shoulder blades and touching the buttocks.

235

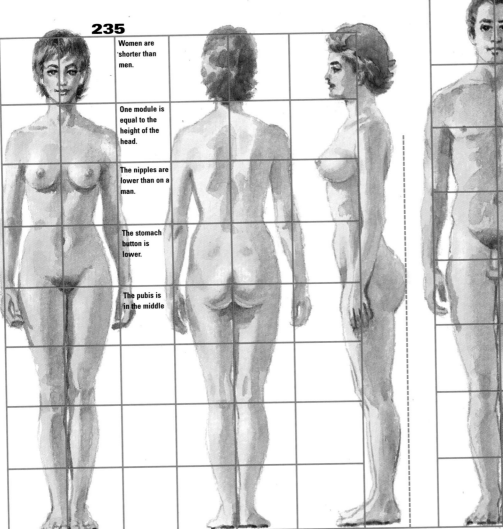

Women are shorter than men.

One module is equal to the height of the head.

The nipples are lower than on a man.

The stomach button is lower.

The pubis is in the middle

237

238

GASPAR ROMERO'S PALLET

239

FRANCESC SERRA'S PALLET

240

CHARLES REID'S PALLET

The seated figure offers a canon of six heads but with the model lying down the canon becomes a simple reference to bear in mind. Of course **Gaspar Romero** has this canon in mind and when the drawing is done he goes over it again then decides the drawing of **Pepa** is finished (fig. 237). We will now talk about the colors involved in skin colors. **Gaspar**'s pallet is made up of cadmium lemon yellow, yellow ochre, raw Sienna, cadmium red, burnt sienna, carmine, sky blue and ultramarine blue (fig. 238). Every artist has his own pallet. I remember the pallet used by the celebrated artist **Francesc Serra** for painting skin color in oil paints. White, yellow ochre, English red, carmine and ultramarine blue (fig. 239). And here we have the pallets used by the famous American watercolorist, **Charles Reid**, light cadmium yellow, yellow ochre, cadmium red and sky or cobalt blue. And for making the dark skin tones he mixes the aforementioned colors with Hooker green or ultramarine blue (fig. 240).

But let's see how **Gaspar Romero** paints this nude of **Pepa**.

He begins with a light skin colored wash of abundant water, cadmium lemon yellow, ochre and a speck of sky blue. After the first coat has dried he adds a very tenuous wash of sky blue sketching in the shaded areas. He then starts sketching in the color of the hair with Payne's gray and ultramarine blue (fig. 241). He waits until all this is dry and begins to fill in around the figure with the dark fabric of the sofa using light blue which is a mixture of sky and ultramarine blues (fig. 242).

241

242

Fig. 237. The drawing started with a number 2 pencil and was redrawn with a 2B.

Figs. 238, 239 and 240. The color ranges for painting skin tones according to the pallets of Gaspar Romero, Francesc Serra and Charles Reid.

Figs 241 and 242. Gaspar begins to paint in a light tone and in general washes for the hair, body and the shadows and tones of the sofa.

Painting Nudes in Watercolors

243

244

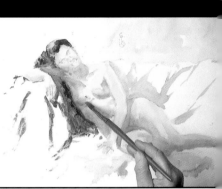

He changes his plan and paints the background bordering the sofa with a very light, almost imperceptible gray wash of cobalt blue and burnt Sienna. He reinforces the hair color and practically leaves it for finished. He finishes this stage by intensifying the color of the shadows with yellow ochre, sky blue and a speck of cadmium red (fig. 242).

After this general stage **Gaspar** uses an eraser to rub out the pencil but leaves some indication marks which allow him to continue structuring the forms of the nude.

And he continues by first intensifying the shadow of the model on the sofa which makes it necessary to intensify the shadow on the right of the model. He makes use of this mixture diluted with water to draw and model the thighs and the legs and he finally adds a touch of color to the hair, a red stain which suggests a ribbon (fig. 244).

Finally he decides to paint the sofa but with an approximate color which is lighter than that of the sofa. He employs a mixture of cadmium lemon yellow, ochre, a bit of carmine and even less of cobalt blue (fig. 245).

He cuts away at the upper part of the figure on the sofa, on the right hand side (the left of the model) (fig. 246). Now he paints the features of the face and to eliminate the problems of drawing a bent head, that is the models head leaning on her shoulder, he turns the board to a vertical position in relation to himself (fig. 247).

In this and the normal position he paints the eye-brows, the eyes —ultramarine and cobalt blue— the lips and he models the nose (fig. 248).

245

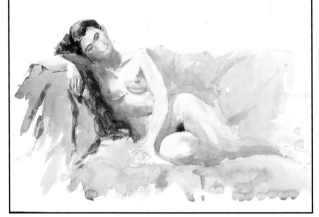

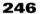

Figs. 243 and 244. He finishes the hair and paints the first touches of the shadows on the body and also intensifies the shadow thrown across the sofa. He adds a red stain to the hair which represents a ribbon.

Figs. 245 and 246. He intensifies and perfects the shadows of the body and face. He paints the general color of the sofa and outlines the figure with intense shades of the same sofa.

246

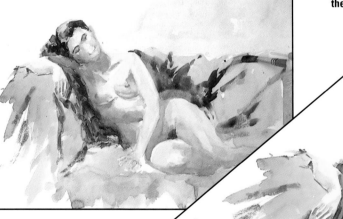

247

Fig. 247. Gaspar, having difficulties with the features of the face, turns the board around in order to work on the face in a more comfortable way.

Gaspar opens up whites and reduces tones on the thorax and on the stomach, the breasts and the neck. It is a continual game of painting and absorbing, opening up whites and reducing colour and even modifying forms (fig. 249). From this point on the watercolor could be considered finished except for the addition of some dark touches on the sofa.

"I'll leave it like that", says **Gaspar Romero**. Retouching or adding more forms or colors could spoil this finish which to me seems correct. As the great watercolorist, **Federico Lloveras** used to say: *"The most difficult part of a watercolour is knowing what not to paint"*. **Gaspar Romero** is right and he signs the painting.

Figs 248, 249 and 250. Retouching the facial features and adding the last finishing touches. In figure 250, Gaspar Romero painting a nude.

Fig. 251. The last step and the finished watercolor signed by Gaspar Romero.

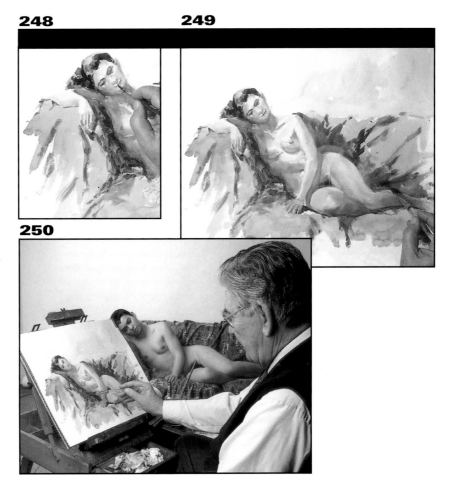

248 **249**

250

251

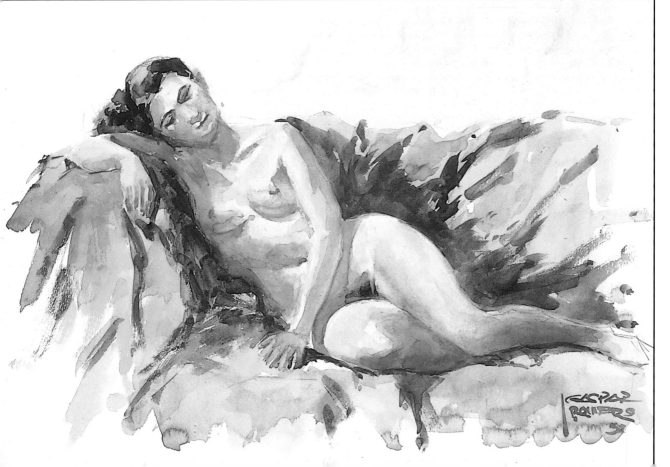

Painting Nudes in Watercolors

Jordi Segú also paints watercolors and he is also one of those who goes every day, from 7 to 9 to the Barcelona Artistic Circle to draw nudes with magnificent results like the one you can see in figure 252.

Segú is going to paint the model **Amelia**, sitting on a stool covered in a sheet of red velvet (fig. 253). You can see the finished drawing, done with a 2B pencil on Fontenay de Canson watercolor paper, in figure 254. The background is painted with a light gray wash. In figure 255 you can see the first steps with a few touches of skin color to the shaded parts —English red and a bit of ultramarine blue—, and a slightly darker color for the shadow on the cheek and neck. In the following image **Segú** paints a wash which covers the body but with the white highlights reserved for later. He darkens the color of the shadows, especially on the face and torso (fig. 256). He makes a transitional step by working on the legs and the general modelling of the body. He also begins work on the velvet cloth over the stool (fig. 257).

252

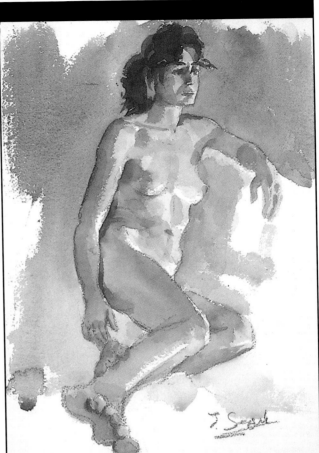

Fig. 252. Jordi Segú. One of the watercolors painted by our guest artist in the Barcelona Artistic Circle studio.

Figs. 253 and 254. The model and the drawing with a very light gray background.

Figs. 255 and 256. The first touches of color.

253

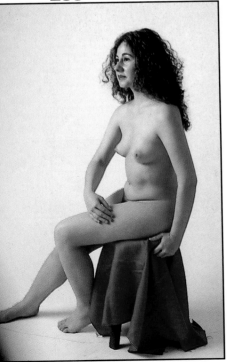

254

255

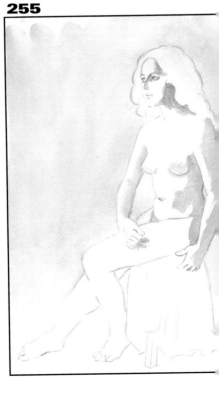

Here in figure 258, **Segú** works on **Amelia**'s face, eyes, nose and mouth in a light tone and he also dilutes and blends what were up till now stains of the shadows of the nose and the cheeks. He begins the painting of the hair and continues work on the body in general which now has more color in the light areas. Finally, at this stage, he models **Amelia**'s red stool. He finishes this nude by finishing the head then by reinforcing the modelling of the face. He paints and finishes the hair with ultramarine blue, carmine and Payne's gray. He finishes off the red velvet cloth but he pays more attention to the detail of the body.

"Perfect, Segú", I tell him, "You can sign with satisfaction".

256

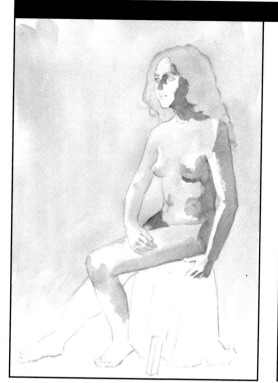

257

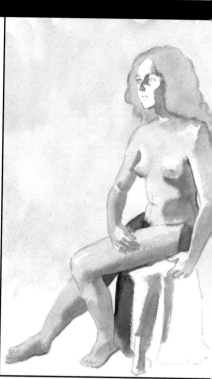

Figs. 257 and 258. Here the color is already more effective, more intense particularly in figure 258, in which we can see the facial features sketched in a light tone and the hair which is half done. Also notice that the modelling of the body and stool is quite advanced, almost in the last stages.

Fig. 259. This is the finished work. A watercolor by Jordi Segú, carried out with his usual technical finesse.

258

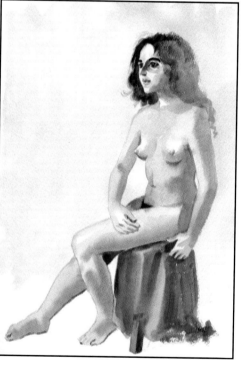

259

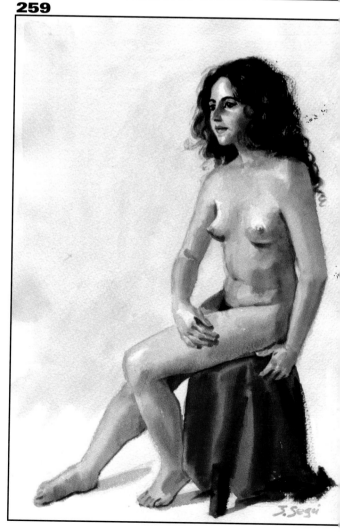

The Perspective of the Human Figure

The human figure just like all other bodies is subject to the laws of perspective. The basic law is that the horizon line determines the height of the figure. This is logical if we remember that the horizon line *is an imaginary line which is always found in front of us at the same height as our eyes looking forwards*. Remembering this basic rule we have here various examples of the application of perspective to the human figure. Please read the following texts while consulting the corresponding images.

Figure 260. Draw the horizon line (HL) and situate the vanishing point (VP1) by drawing figure A in the foreground. Then draw oblique lines from the head and feet of figure A to vanishing point (VP1). Then indicate and draw in point B and vertical D where we will draw a second figure.

Figure 261. Once the second figure is positioned we can determine the proportions of both figures by tracing a series of oblique lines, E, F and G etc. to vanishing point (PF1), coinciding with the height of the head, the breasts and the waist of figure A.

Figure 262. We are now going to draw a third and fourth figure. The third, indicated by H, will be the same height as B, for which it is simply necessary to trace the horizontals I and J which determine the height and proportions. To draw the fourth figure, indicated by E, you must first draw a diagonal from E to the second vanishing point (VP2) on the left hand side of the horizon line.

Figure 263. It is just necessary to draw a horizontal from vanishing point 2 (VP2) to point K, just above the horizon line, in order to obtain the vertical L which corresponds to the height of the fourth figure E.

260

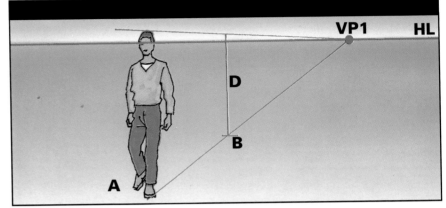

261

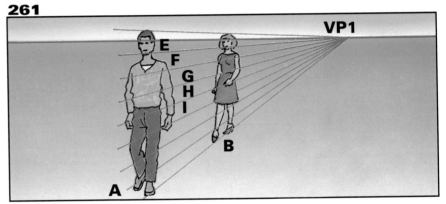

262

263

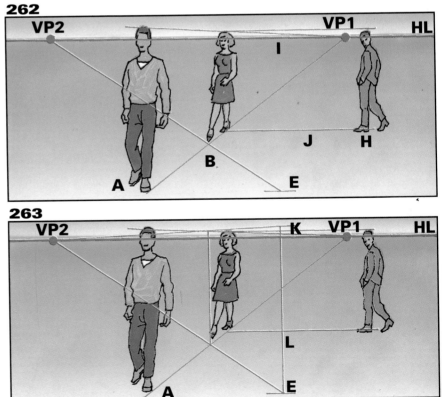

264

Figure 264. And here is the fourth figure drawn in perspective at a slightly higher height than the first figure A because it is nearer, more in the foreground.

Figures 265 and 266. I will now present two special cases, two illustrations or pictures in which the horizon is at a lower level or at a higher level. As you can see, this does not present any problems. It is the same formula as before. Once the first figure A is in position (fig. 265) and the diagonals have been

265

266

drawn to the vanishing point (VP2), the second figure is positioned further back with the diagonals vanishing at vanishing point 1 (VP1). In the next figure 266 the problem is the same but the position of the figures is different in respect to the vanishing points.

Figure 267. To work out the perspective of a seated person we start off with the height of a standing figure, of the ideal height of eight heads, and we apply a height of six heads to the seated figure.

267

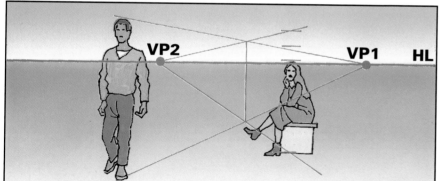

Figure 268. In the case of a figure positioned in the middle ground and on a higher plane you have to imagine that this figure is actually on the same plane as the other figures and calculate the perspective height according to this idea. All you have to do then is move this height to the highest position or level in order to resolve the problem. The same solution can be applied when the figure is found at a lower level than the other people.

268

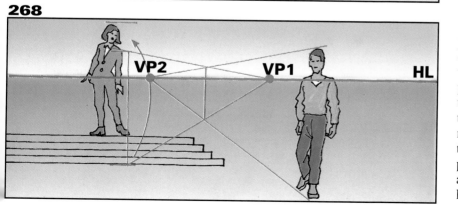

Painting a Landscape in Watercolors

269

Here is a mountainous landscape, some 120 kilometres from Barcelona. It is a subject that draws your attention because of the composition, colors and contrasts. A good reason to paint (fig. 269). I painted it in **Paco** the photographer's house where I developed it step by step. You see, a few days ago I travelled to this spot and made a sketch from nature which you can see in figure 270. As always, I took my Nikon camera and took a photo. I blew it up to 18 x 24 cm and decided I would make this painting from the sketch and photo.

So here we are with **Paco**. I am ready to paint and draw and **Paco** is preparing the camera and flash to take photos while I draw. And this is the finished drawing on 47 x 32 cm Fontenay de Canson paper, with the cross in the center to facilitate the calculations of dimensions and proportions (fig. 271 on the next page). And as always I begin painting the sky, adding clouds —ultramarine and cobalt blue for the sky and ultramarine and a little burnt umber for the clouds—, as I did in the sketch. But as you can see from the photo, there were no clouds that day. It is almost always a good idea to add clouds to a clear sky as it helps the composition (fig. 272).

270

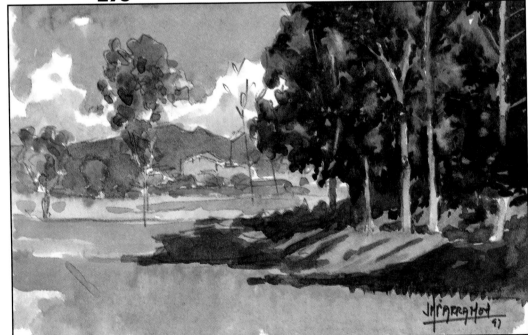

Fig. 269 (above). The subject. A landscape to be painted. In the foreground there is a mass of trees and a bit of earth with the shadows of the trees across it, and which due to its size, definition and contrast determines the idea of depth. See the tonal and chromatic value of the tree in the middle ground and of the farm house and hills in the background, which, because of their size, color and contrast, illustrate the impossible; the third dimension.

Fig. 270. If you go this way by car and you take with you your watercolor materials for taking notes and sketching, it is almost impossible that with a landscape like this, not to stop the car, get out and do some sketching. That is what I did and I also took a photo. That was the origin of the landscape I am going to paint now.

I now move on to the large group of trees on the right. I repeat the process that I developed in the sketch I made from nature (fig. 270), that is, first a uniform coat of permanent green representing the groups of leaves receiving the sunlight (figs. 273 and 274), without introducing any changes yet.

Oh! And just as I did in the sketch, while painting this first greenish ochre I take great care to reserve the tree trunks and branches. As you can see I also painted in the hills in the background with Prussian blue, a bit of carmine and another spot of burnt umber.

271

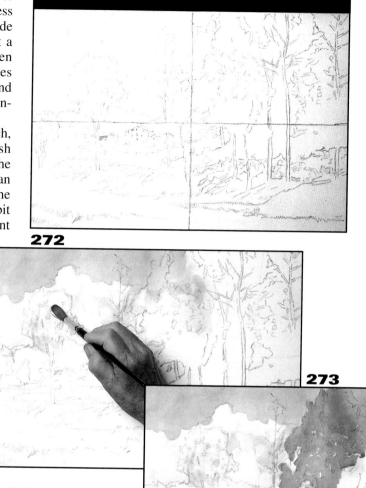

272

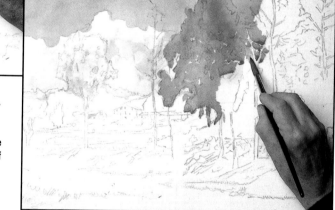

Fig. 272. In the photo of the model the sky is clear but I added some cumulus clouds which I did in the sketch. On the subject of clouds, I recommend that you practice painting them from nature. This will enable you to paint them from memory in cases like this.

Figs. 273 and 274. I paint the large grove of trees in the foreground beginning with the color of the bright patches with this greenish yellow and at the same time I take care to reserve the spaces for the tree trunks and branches. In figure 274, the greenish yellow of the trees is finished and I paint the hill in the background and I harmonise and reinforce the gray of the clouds.

Fig. 271. First one has to draw. I do so as always by drawing in a cross in the centre of the paper in order to calculate the dimensions and proportions of the theme.

273

274

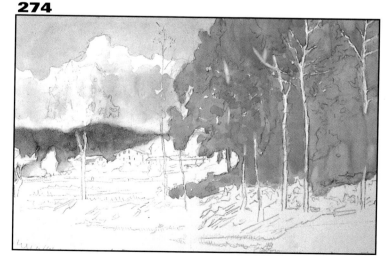

Painting a Landscape in Watercolors

I begin now with the dark green color of the shade in the big group of trees. This is a dark green composed of a mixture of emerald green and carmine with the occasional addition of Prussian blue and burnt umber. And so we begin this game of reserving areas for the tree trunks, branches, holes, leaves and groups of leaves. This is a neverending job which you can observe in figures 275 to 282 of this double page. I am going to comment on the contents of each of the eight illustrations.

In figure 275 I begin work on the dark green, almost black, leaving some small holes. In the next figure 276, the entire shady area is covered with greenish black. Notice that there is a total contrast between the light and dark green and the white of the reserved areas for the trunks and branches. Now you will notice that in figure 277 there are some tinges of a slightly darker green than the initial green. This is continued throughout the painting of trees in figures 278 and 279.

As you can see in these images I left the trees to start painting the grass.

275

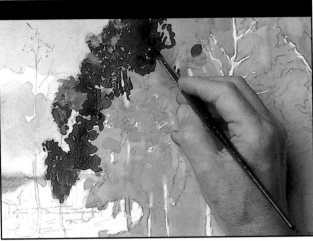

276

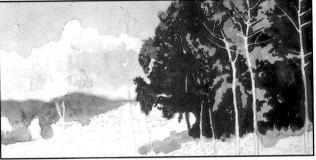

277

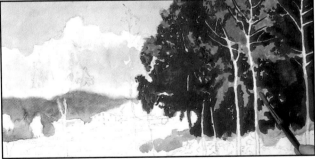

278

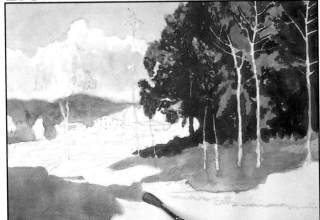

Figs. 275, 276 and 277. With a dark green, almost black color, I paint the shaded area of the grove of trees. This I do in a flat color, without variation or tone changes as these will come later with the modelling. But there are variations in the light yellowish green of the sunlight catching the leaves. In figure 277 you can see how I add a thin coat of slightly darker yellowish green.

Figs 278 and 279. Now I leave the trees in order to clear my mind of them. I mean that I need to forget about them for a while, to forget about leaves, trunks, reserves of white and of shade and start working on other things in other areas. So I paint the grass, the earth and the shadows formed by the trees and the tree trunks in the foreground which apart from letting me forget about trees, draws me once again into the overall painting.

279

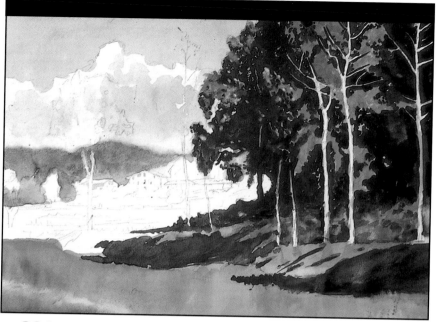

I also paint the color of the earth at the base of the trees. Permanent green and a bit of yellow for the grass and dark cadmium yellow and a bit of carmine for the earth.

But in figures 280 and 281 I go back into battle by opening small white areas and lightening small zones, by the technique of dampening (280) and absorption with absorbent paper (281). This painstaking and laborious task of sorting out the lights and shades of the trees is reflected in the figure 282. Here the tree trunks are almost finished and although there are some details left to do on the big group of trees, I can leave them to paint the light shades of the tree in the middle ground and the light color tones of the earth.

280

281

Figs. 280 and 281. Here I return to the trees. Now the work consists of finishing off, of lifting off white spaces or light greens by dampening and absorbing color with a synthetic paintbrush (fig. 280) and absorbing with folded paper (fig. 281). This is done over and over again until the color is lifted off the paper. In some cases these light spots are for repainting in other tones.

282

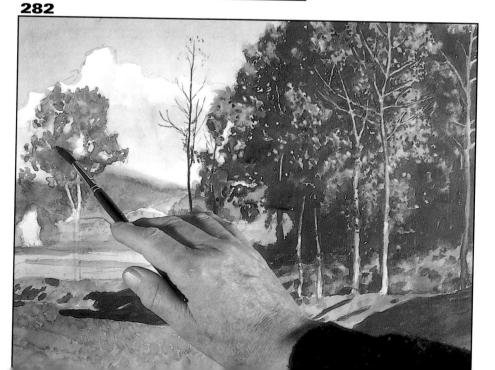

Fig. 282. We finally arrive at the result, the finish shown in this image, of the color of the trunks and branches sorted out. This surface will not be modified again and will appear practically the same in the finished watercolor. In this same image I also paint the light tones of the tree in the middle ground and also the earth colors of the middle ground and the profile of the two leafless trees in the center, next to the large group of trees. The grass also undergoes a notable change and is near to being finished.

Painting a Landscape in Watercolors

283

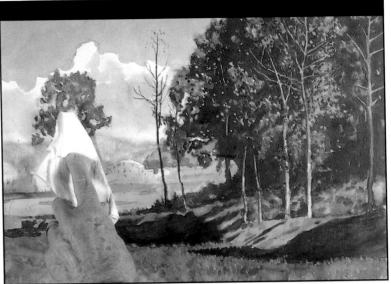

I did not like the color of the mountain in the background. It was a blue with an excess of carmine and tending towards violet so I changed it for a more bluish gray color which correlates more with the distance and atmosphere, don't you think? No problem. As you already know, wet it with a synthetic brush with light strokes and then absorb with absorbent paper. Also notice in figure 283 how I worked on the grass. In figure 284, I painted the parts of the trees in shade in the middle ground. Now look at the way I painted the trees and bushes on the left hand side leaving the farm in the distant house for the moment. And notice also the treatment of the grass. The painting of the farm house, the grass and of the entire view can be better appreciated by looking at the finished watercolor on the next page (fig. 286). But we still have to touch up and retouch, to intensify with black and not with mixtures of emerald green, carmine and Prussian blue but with **black-black**. I concentrate on the darker areas of the grove of trees. I reinforce the carmine tendency of the tree trunks and branches and I change the tones of the shadows cast by the trees across the fragment of earth in the foreground. I diversify the colors and tones of the grass by reinforcing and re-absorbing, with areas of earth color added to the area of grass in the foreground on the left hand side. And I will say no more. So much work and effort has been worth it. It was, it is the last watercolour of this book, which I hope and desire with all my heart, will help you to paint better watercolor paintings.

284

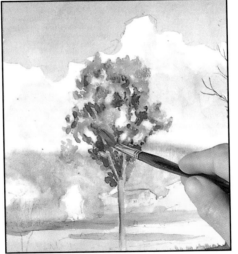

Figs. 283 and 284. Here we have, as they say in Italian, a *pentimento*, a regret or mistake because here I found that the color of the mountain in the background had a violet tendency which did not correspond with the more bluish tone in the sketch. I changed this by dampening with light strokes from a synthetic brush and then absorbing with absorbent paper (fig. 283). I eliminated the color of the mountain in the background with the idea of changing it. Then I returned to the tree in the middle ground and painted the shade on it.

285

Fig. 285. See the change in the color of the mountain in the background and notice the addition of this grayish tree on the left of the frame and the finished trees in the background. It looks as if the only element left to paint in order to finish the painting is the farm house, but...

286

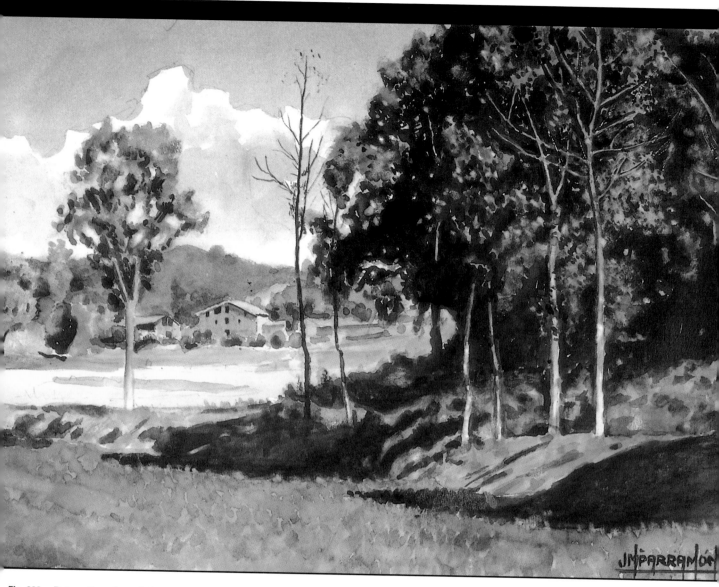

Fig. 286. ...But no. Now the painting is finished. But apart from the complexity of the construction of the farm house and its surroundings, with its lights and shades, its roofs, windows and doors, I also painted this series of small trees in front and behind the houses. I slightly modified the form of the shadows created by the group of trees. I retouched the grass by adding some touches of earth color to the fringes in the foreground on the left and finally I heightened the contrasts in the large group of trees by painting the darkest areas directly in black. Then I left off and signed while thinking of Lloveras' anecdote and Fortuny's advice which I transcribed underneath the watercolor of daisies and anemones by Carmen Freixas on page 29.

I am going. I have finished the watercolor and this volume, the last of five volumes which comprise *Practical Course in Watercolors*. It has been a pleasure drafting the texts and painting some of the watercolors and developing step-by-step processes in this collection. It has been a pleasure being with you, explaining techniques and clearing up concepts. Regretfully, I am going. But I hope we will meet again in other books with myself drafting the text and illustrating and you painting excellent, magnificent watercolors.

Glossary

A

Absorbent paper. A kind of paper which is characterized by its high capacity for absorption. Very useful in painting in watercolors for absorbing color and creating white areas. It is usually found at home in the form of toilet paper, paper towels, tissues or napkins.

Agglutinant They are those liquid substances used to amass or bind together dust or chalk pigments. Watercolor pigments or colors are bound with water and gum arabic and also glycerine, honey and a preserving agent.

Airbrush. An implement which emits colour in the form of a spray thanks to an air compressor. The process of painting with an airbrush is called spray painting or airbrushing. With this method it is possible to paint flat colors, graded washes or diffuse outlines. With the help of stencils more defined figures or bodies may be reproduced.

Asymmetric. When we see in a picture that the structure and distribution is intuitive without following rules or laws but maintaining an equilibrium of the masses in respect to each other, we have before us an example of asymmetry.

Atmosphere It is visible in landscapes and marina especially when the motif is against the light. It is characterized by the air between the back and foregrounds which appears as successive layers of mist and as a consequence the stronger contrasts lie in the foreground and there is less definition and paler colors further away.

B

Blue, cyan It is one of the primary pigments of the spectrum. It is a neutral blue equivalent to Prussian blue. It is a color that appears in the watercolor spectrum under the name of cyan blue.

Botanical painting. A field of painting which has its origin in the XVIII century and investigates the part that vegetables, flowers, trees and fruit play in natural history which it does from a scientific point of view.

C

Cartone. An Italian word referring to a drawing done before working on the definitive painting. It is done on a type of cardboard or illustration board which acts as a support. This kind of study is usually done in a minor tonal range and serves as a working model for murals, mosaics, stained glass windows, frescos and tapestries etc. When the *cartone* is ready it is transferred to the canvas or wall by means of a grid system in order to draw the basic outline

Cat's tongue. This is the commonly used name for a Filbert paintbrush. They are flat or round hog's hair brushes which come in different sizes for watercolor painting.

Cennini Cennino. An Italian artist and teacher who wrote *Il libro dell'Arte*, the first art book to be written in Italian and the word "wash" was introduced with reference to watercolors.

Chalks (Cretan earth). A stick of color which is composed of white, limestone rock formed from Cretaceous sediments. The product consists of pigments, oil, water and a glue that acts as an agglutinate. It began to be used during the XV century to highlight the finish of drawings. It is similar to a pastel but more compact and it produces a more solid line. These days they come in a wide range of colors.

Chiaroscuro. Rembrandt was the great master of chiaroscuro. In his pictures the areas in which forms and colors are enveloped even in the darkest shadows, are still evident. In his books on the teaching of drawing and painting Parramón has always defined this term as "the art of painting light in the shadow".

Color, broken. The range of colors made up of the mixture of two or more complementary colors in unequal proportions.

Color, complementary. When you mix two primary colors such as yellow and blue you obtain a secondary color, green. This is complementary of the primary color which was not used in the mixture, in this case, magenta. If you paint a band of green juxtaposed with a band of purple above or below it, you will obtain the biggest color contrast possible. If you mix two complementaries in unequal proportions you will get a grayish, dirty color which belongs to the range of broken colors.

Color, local. This is the red of a cherry, the yellow of a lemon or the blue of a flower. The innate color of an object when it is not affected by light or shade or reflections.

Color, primaries. The basic colors of the solar spectrum. They are red, green and intense blue. The colors cyan blue, purple and yellow are primary pigments.

Color, reflected. This is a color which exists on all bodies as a direct or indirect reflection of the light and color from other bodies.

Color, secondary. These are colors of the spectrum which are composed of the mixture, in pairs of two primary colors. The secondary colors of light are cyan blue, purple and yellow and the secondary pigment colors are red, green and intense blue.

Color, tertiary. These include light green, emerald green, ultramarine blue, violet, carmine and orange. There are six colors in total which are obtained by the mixing of primaries and secondaries in pairs.

Color, tonal. This is the color produced in the shaded parts of bodies or objects.

Colorism. A form of painting which gives more value to colour than to volume. This forms part of contemporary tendencies.

Colorists. Van Gogh, Matisse and the Fauves initiated the formula of painting used by colorists. This gives importance to color over form bearing in mind that by painting only in colors without shadows it is possible to explain the forms of things.

Contrast. The evident opposition or difference between colors highlights their tonal qualities.

Copper plate printing. A method of printing which involves the coating of a copper plate with a waxy varnish. When this has dried one draws with a stylus

and by removing the wax the copper is left exposed. Any possible mistakes are repainted with the varnish and the plate is then submerged in an acid bath which corrodes the metal. After the necessary time has passed the varnish is removed from the plate and prints are then taken from it. This method of printing is known as etching.

Crayons, colored. These are made with pigment and wax which acts as an agglutinate. When heated, these components melt into a uniform paste which once dried forms cylindrical sticks. They are used with a rubbing action which makes it possible to paint light colors over dark. Although they are solid they can be dissolved in turpentine.

Cutter. A sharp blade which is used for cutting paper with great precision. This can be withdrawn at will into a metal casing or handle. When cutting paper with this implement the use of a metal ruler is recommended.

D

Deckle edged paper. The irregular edge of good quality watercolor paper.

Deer's hair. Also known as the Japanese paintbrush, it is made of deer's hair attached to a bamboo handle it is similar in quality to an ox hair paintbrush. The flat Japanese fallow deer brush is recommended for painting washes and covering large backgrounds.

Direct painting. The technique of painting called *alla prima* in Italian, *au premier coup* in French and *a la primera* in Spanish. It is a technique which consists of painting in one single session, painting quickly and with out going back over what has already been done.

Dominant color. Dominant is a word which derives from musical terminology and indicates the fifth grade in a musical scale. In other words, the most dominating note. Through affinity the same denomination is applied in painting to designate the dominant relationship which a certain color exercises over a determined color range (warm, cold or broken colors).

Drawing, free-hand. This is the method of drawing without the help of measuring instruments such as rulers or compasses.

Dry-brush technique (*frottis* or scrubbing). This is a watercolor technique which consists of scrubbing or dragging the paintbrush with a little paint across a coarse grained paper.

Dry watercoloring. This is not some new watercolor technique but actually describes the traditional method. The term "dry watercouloring" is employed to differentiate from the "wet on wet" technique.

F

Fauvism. An artistic movement which started in Paris in 1905. It is a style which is characterised by the use of strident color, flat forms and by the juxtaposition of primary colors. The art critic, Louis Vaux Celles used the word *fauve* (wild beast in English), when he was moved by the violent colors that saturate their works. The members of the group were Matisse, Derain, Vlamink, Roualt and others.

Ferrule. The metal tube or neck found at the base of a paintbrush which holds the hair used for painting.

Flesh tones. A term used to denote the range of tones and shades used for painting skin.

G

Geometric study. A drawing done as a study for a picture in order to sort out the form and basic composition of a motif. It reduces forms to their basic geometric forms, cubes, triangles, rectangles and cylinders etc.

Gum arabic. A vitreous vegetable agent derived from a secretion of the African Acacia tree. Dissolved in water it is used as a glue in watercolor, gouache or tempera.

Gouache. A paint of French denomination which is also commonly known as tempera. It has similar qualities to watercolor and is composed of pigment, plaster, honey and natural glues which are soluble in water. It is characterized by its opacity and covering power. It is capable of covering any previously applied layer of paint. It has a matt tonality and hardens very quickly.

Grain. This denotes the distribution and regularity of the fibres in paper. Fine grained paper is used for graphite pencil drawing while course grain is more adequate for watercolor painting.

Golden section. The golden section was a system of proportions established by the architect Vitrubio and which has its origins in the works of Euclides. The method consists of the positioning of various points which divide space in unequal parts which offer a harmonic and attractive result. If you look at Renaissance painting you will see many examples of the use of the golden section.

I

Illustration board. The result of the compression of various layers of wood pulp normally gray or brown. Quality watercolor paper often comes mounted on this resistant supporting board. If you should want to reproduce a watercolor by a photocopying technique the use of normal paper is preferable. An illustration board does not give good results when reproduced by a scanner system.

Induction of complementaries. This denotes a phenomena derived from simultaneous contrasts which follow the rule which states that "to modify a determinate color it is only necessary to change the background color which surrounds it".

L

Lead pencil (graphite). The name of what we know as the common pencil composed of a graphite lead and clay inside a wooden cylinder.

Lineal drawing. Graphic representation consisting of lines drawn without any shading or tonal values. It is useful for drawing in preparation for watercoloring because if we draw the shadows the watercolor could become dirty when mixed with the graphite lead. Lineal drawing is also known as industrial drawing.

Liquid eraser. A blocking agent. Liquid latex eraser used in watercolor painting to reserve small white areas. When applied it remains visible thanks to slight coloration. One can paint over the eraser which will not accept the color and is finally iliminated by rubbing with the finger or a normal eraser when the painting is finished. It is not advisable to use sable or ox hair brushes but synthetic brushes but even then it is necessary to clean the brush thoroughly immediately after use.

Liquid watercolors. Those colors which are similar to aniline colors which provide an intense color of great transparency and luminosity. They are generally used for painting backgrounds or graded washes. They come in small glass pots.

M

Malleable eraser. A type of eraser made of a material similar to plasticine which enables it to be shaped into a point etc. This facilitates the drawing of whites with a eraser. Apart from rubbing out graphite from a lead pencil it useful for charcoal, compressed charcoal and pastel etc.

Media. Plural of medium.

Medium (1). A term used to designate a certain pictorial technique or material e.g. watercolor, oil paint or gouache are three different media.

Medium. (2). An acidic substance which dissolved with watercolor increases its stickiness and color quality. It also acts as a disperser by getting rid of any possible greasy deposits in the water

Mongoose hair. Hair used from this animal is very good for watercolor brushes. A paintbrush made from mongoose hair is slightly harder than a sable brush. Due to its rigidity it offers more tension but it is equally compact and has a good point.

Monochrome. Term used to describe a work which has been painted in one color only. A clear example of this are paintings done only in sepia, black or Sienna.

Motif. A word used by the Impressionists and particularly by Cézanne instead of the word "theme" to define a model painted in a spontaneous way without any preparation, just as it appears in reality.

N

Neoclassic. The name given to the artistic style which has its origins at the end of the XVIII century and the beginning of the XIX century in Italy from where it spread across the rest of Europe. It is characterized by the re-evaluation of the classic, Greco-Roman art and its resurgence in the academic institutions. Notable artists such as Louis David or Anton Rafael Mengs belonged to the neoclassic movement.

O

Outline. Preparative non-definitive stage before painting. Great artists through history habitually made sketches or studies before starting on any important work.

Ox bile. A substance that when mixed into water used for watercolor painting helps as a dampener. It comes from ox's bile and is sold in jars and it also comes in a concentrated form.

Ox hair brush. A paintbrush made of hair from the back of the ox. It is used primarily for covering large surface areas with color. For this purpose it is quite usual to use sizes 18, 20 or 24. This type of paintbrush is an excellent compliment to sable hair brushes for watercolor painting.

P

Paintbox. A metallic box used for storing and mixing paints. When the box is open the indentations in the lid serve as receptacles for mixing colors. In the past, paintboxes were made from sea shells or ivory.

Perspective. The way of representing three dimensions on a flat surface plane. There are three different types of perspective. Linear perspective which gives a frontal view of the subject. Oblique perspective is when the subject is positioned obliquely in respect to the viewer and aerial perspective when the subject is viewed from a higher than normal viewpoint.

Pigment. A coloring agent of animal, vegetable or mineral origin which is used to dye paint into different colors. Generally the powdered pigment is mixed with an agglutinating agent, oil, gum arabic or acrylic etc., thus producing the pictorial medium.

R

Range of colours. Equivalent to the system of musical notes (do, re, mi, fa etc.) invented in the XI century and defined as "a scale of perfectly ordered sounds". In the Renaissance this was applied to colors and since then there has been a distinction between hot, warm and broken color ranges.

S

Scrub. *Frotter* in French. In watercolour painting, to scrub is the same as dry brush which consists of dragging or scrubbing the brush with only a little paint across course grained paper.

Successive images. This principle was introduced by the famous physicist Chévreul who discovered that "the observation of a color produces, in sympathy, the appearance of its complementary color".

Sumi-e. A traditional, oriental painting technique which originated with Zen philosophy. One paints with Chinese ink using a paintbrush made of stag hair and a support made of bamboo.

Support. This defines the object which holds the painting surface. Sometimes the support needs preparation according to the system or technique we are going to use. The support necessary for watercolor painting consists of a sheet of paper mounted on a hard, compact surface.

Symmetry. A pictorial composition defined as "the repetition of the elements in a painting on both sided of a central axis".

Synthetic hair. A paintbrush introduced onto the market with great success ten years ago which has qualities very similar to those of the sable brush but is notably cheaper. When mixed with sable hair the quality is superior and can be found under various names.

onalist. As opposed to colorists, nalist develop the modelling and olume of their models through he painting of the effects of light nd shade.

opographer. . Name given to raughtsmen who drew and pained landscapes, gardens, monuents or other types of architeconic spaces in England in the VIII and XIX centuries. These raughtsmen were hired to illusrate journeys or expeditions of a cientific nature.

aluation. In drawing as in paing the volume or modelling is btained through tonal valuation f the model which at the same me is achieved through the comarison and resolution of the ffects of light and shade.

eduta. Drawings of the ancient nonuments of Rome which were ery popular in the XVIII century, articularly in England, when ey were illuminated with watercolors, the popularity of this kind f painting started.

eil. Coat of paint placed on top f another which has the effect of tensifying or modifying it.

W

Warp. The undulations which may ffect the flat surface of the draing paper as the result of damening or wetting it. This happens ore often when the paper is thin.

Wash. Name derived from a style f painting employed by most of he Renaissance and Baroque artists which consist of linear drawing without shading, painted with water and just one color, generally sepia, using the watercolor technique. It is a very appropriate technique for learning to paint in watercolors. Different colors can also be used for the wash such as blue, green or black.

Water stand. A ceramic or metal jug which together with a washbasin or bowl was used until a few years ago for hand washing in private houses that had running water. A water stand may come in different shapes or sizes and with different forms of decoration which have made it a popular pictorial motif.

Wet on wet. Technique which consists of painting over a recently painted area or zone which is still damp with another coat but controlling the degree of dampness according to the form and effect wanted by the artist.

Bibliography

Buset, M. *Modern Pictorial Technique*. Librería Hachette, S. A., Buenos Aires.

Da Vinci, L. A *Treaty on Painting*. Colección Austral. Espasa Calpe, Barcelona.

Fischer, E. *Art and Coexistence*. Ediciones Península, Barcelona.

Hegel, G. F. *Sistema de las artes*. Colección Austral. Espasa Calpe, Barcelona.

Kendall, Richard. *Cézanne by Cézanne*. Plaza & Janés, Editors S. A. Barcelona.

Kendall, Richard. *Monet by Monet*. Plaza & Janés, Editors S. A. Barcelona.

Laymarie, Jean. *L'aquarelle*. Editions d'Art Albert Skira, Geneva.

Laymarie, Jean. *Le fauvisme*. Editions d'Art Albert Skira, Geneva.

Lothe, A. *Traités du paysage et de la figure*. Bernard Grasset Editeur, Paris.

Murray, P. & J. *Diccionary of Art and Artists*. Parramón Ediciones, S. A., Barcelona.

Parramón, J. M. *The Big Book of Watercolor Painting*. Parramón Ediciones, S. A., Barcelona.

Parramón, J. M. *The Big Book of Drawing*. Parramón Ediciones, S. A., Barcelona.

Parramón, J. M. and Fresquet, G. *How to Paint Watercolors*. Parramón Ediciones, S. A. Barcelona.

Pickvance, Ronald. *Van Gogh in Arlés*. Editions d'Art Albert Skira, Geneva.

Rapetti, Rodolphe. *Monet*. Anaya, Madrid.

Reynolds, G. A. *Concise History of Watercolors*. Thames & Hudson, London.

Van Gogh, V. *Letters to Theo*. Barral Editores, Barcelona.

Various Artists. *Vincent Van Gogh*. Arnoldo Mondadori.

Zóbel, F. *Cuaderno de apuntes* (Sketch book). Juana Mordó Gallery, Madrid.

Acknowledgements

The author would like to offer thanks for the help and co-operation of the following people, entities and companies in the writing of this book. To Catalonian Watercolorists Association for their kindness in allowing the reproduction of various watercolors in their possession; to Gabriel Martín for his collaboration in the editing of the texts; to the photographic studio, Villa Masip for their work on the reproduction of the materials and the step by step photography of the development of watercolors by the following artists: to Manel Úbeda of Novasis for his help with editing and production of the photocromes and phototypesetting in this edition; to Jordi Segú for his kind collaboration with the development of various watercolors, and to the artists Carmen Freixas, Mercedes Romero, Antón Martín and José Gaspar Romero for painting various watercolors step-by-step especially for this book.